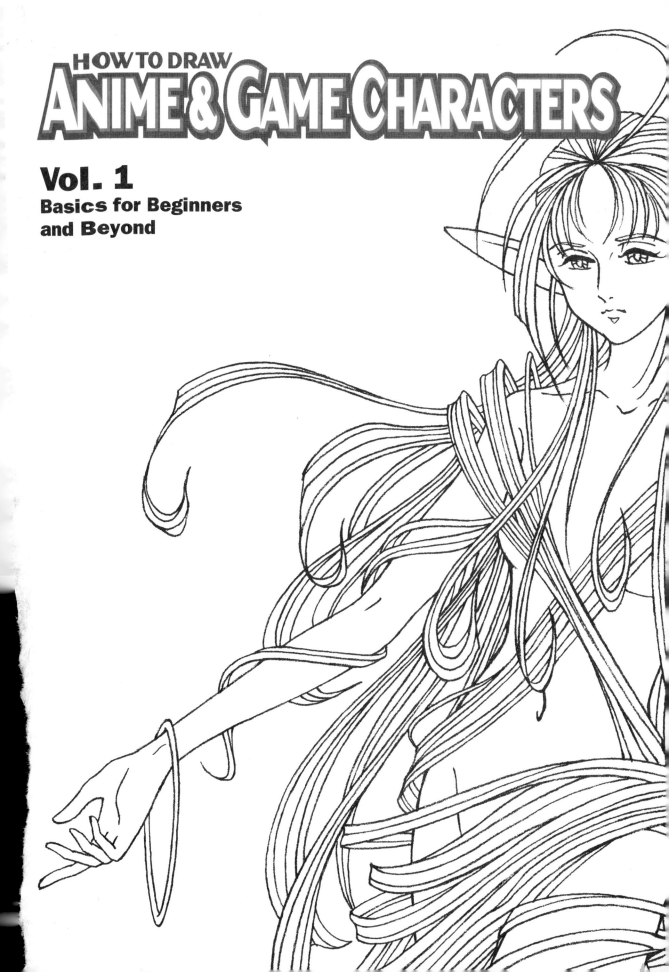

HOW TO DRAW
ANIME & GAME CHARACTERS

Vol. 1
**Basics for Beginners
and Beyond**

Introduction

"I want to have a go at drawing anime and game characters." "I want to draw manga." Or, "I want a job in Graphic Design." If you bought this book, you are probably thinking along these lines. "But I can't draw as well as so-and-so from my Art club, and I am no match for that guy who researches manga and has started his own coterie magazine." There are a lot of people out there who would like to give it a try but don't because they think it looks too difficult and don't know how to go about improving their drawing.

I wrote this book to help these kind of people. Those around you who are good at drawing were not born that way. You too could draw if you could just change your way at looking at things slightly. It is surprising how many people actually draw from memory (off the top of their head). Instead of concentrating on the difficulties involved in drawing the human body, start by taking a long look at how the professionals approach it.

The following is a list of special terms and abbreviations used in this book.

Bishoujo:	Young, pretty girl
Bishounen:	Young, attarctive boy
CG:	Computer Graphics
Gakuen Genre:	School Life Genre
OVA:	Original Video Anime
RPG:	Role-playing Game
SD:	Simple Deformed (Exaggerated)
Shoujo:	Young girl
Shoujo manga:	Girl's comics
Takarazuka:	An all-women theatrical company in Japan

CONTENTS

Chapter 4　Drawing Detail

Chapter5　Now, It's Time for the Real Test

HOW TO DRAW ANIME & GAME CHARACTERS Vol.1
Basics for Beginners and Beyond
by Tadashi Ozawa

First designed and published in 1999 by Graphic-sha Publishing Co., Ltd.
This English edition was published in 2000 by
Graphic-sha Publishing Co., Ltd.
1-14-17 Kudan-kita, Chiyoda-ku, Tokyo 102-0073, Japan

Original design: Motoi Zige
Cover drawing: Koh Kawarajima
English edition layout: Shinichi Ishioka
English translation: Língua fránca, Inc. (an3y-skmt@asahi-net.or.jp)
Japanese edition editor: Sahoko Hyakutake (Graphic-sha Publishing Co., Ltd.)
Foreign language edition project coordinator: Kumiko Sakamoto (Graphic-sha Publishing Co., Ltd.)

First printing: August 2000
Second printing: March 2001
Third printing: May 2001
Fourth printing: August 2001
Fifth printing: November 2001
Sixth printing: March 2002
Seventh printing: August 2002
Eighth printing: November 2002
Ninth printing: February 2003
Tenth printing: March 2003
Eleventh printing: June 2003
Twelfth printing: October 2003
Thirteenth printing: January 2004
Fourteenth printing: July 2004
Fifteenth printing: October 2004

ISBN: 4-7661-1120-6
Printed and bound in China by Everbest Printing Co., Ltd.

Chapter 1
Let's get down to the basics!

Go for it!

Take for example the three points A, B and C below.
What are you looking at when you draw the straight line A → B and the curved line A → C → B? At the pencil? Or at points C or B?

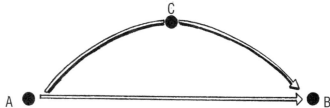

When you are drawing a picture, you must visualize the direction of the line you are drawing, looking not just at the point of the pencil but equally at the three points A, B and C. People cannot draw shapes properly if they are just looking at the pencil point.

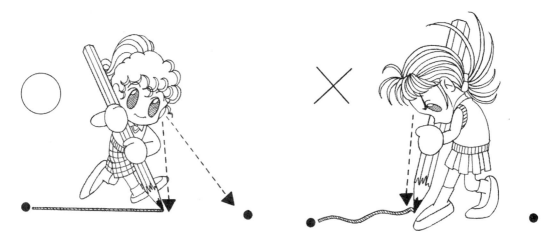

Next, look at the 7 random points below. What can you see?
Just a cluster of points? Or can you faintly discern a shape? You haven't got it yet, have you?

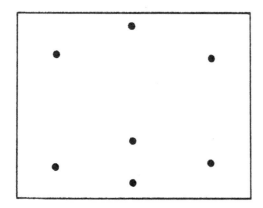
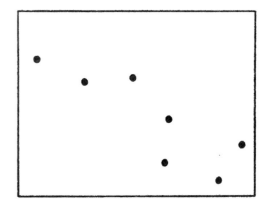

Let's number the points at random. You still haven't got it yet, have you?

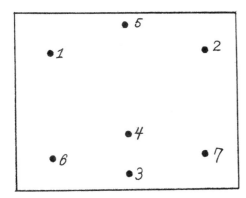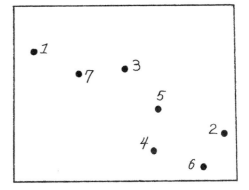

Let's renumber the points to give them meaning. You see, your eyes automatically follow the points in order. Those who can make out the shape from looking at points in this way are able to draw shapes.

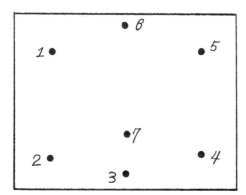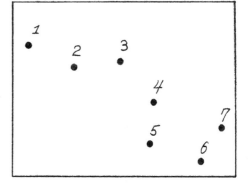

Finally the points are joined up. Random lines join to form a shape. Those talented at drawing can perceive hidden lines within a picture and trace them smoothly. Your ability to draw shapes depends on whether or not you can visualize the points in the correct order.

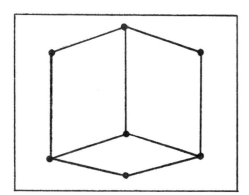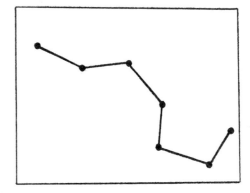

Have you heard of the phrase **motion capture** that is common in the world of computer games and Comuputer Graphics(CG)? It is a useful system whereby the computer reads a person's movements using transmitters placed at certain points of the human body.

Actually this same function is also evident in people who can draw well. Think back to the method of drawing lines A→B explained on the previous page. An entire body or face is mapped out using points situated **at the corners of the eyes, the bridge of the nose, arm joints** etc. This enables a proportional picture to be drawn. Put another way, if you concentrate and look hard, you too can detect where such points are on the face and limbs.

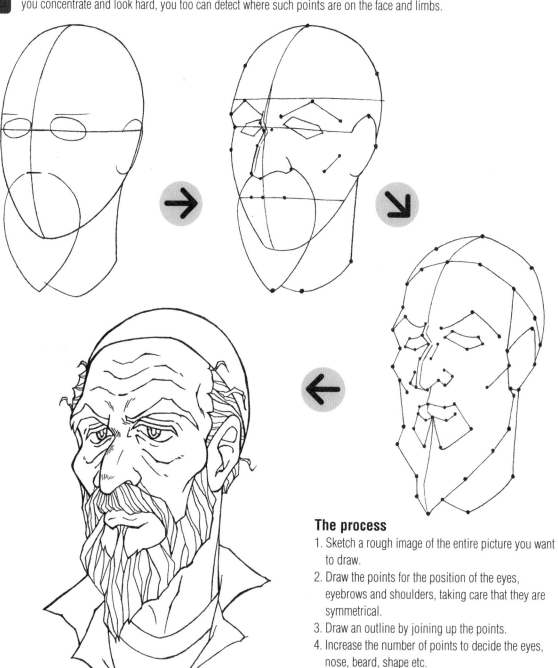

The process
1. Sketch a rough image of the entire picture you want to draw.
2. Draw the points for the position of the eyes, eyebrows and shoulders, taking care that they are symmetrical.
3. Draw an outline by joining up the points.
4. Increase the number of points to decide the eyes, nose, beard, shape etc.
5. You have done!

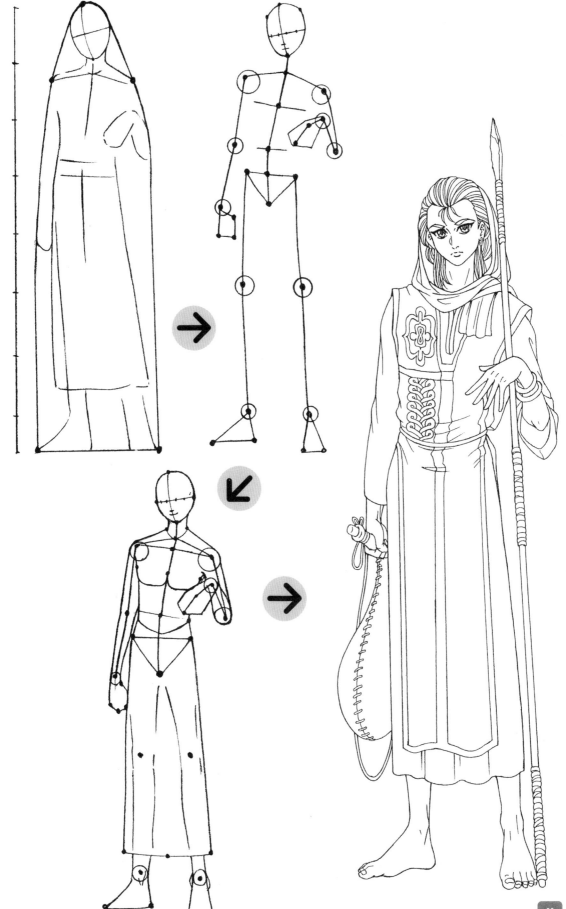

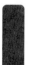

First, where you are going wrong? Let's compare an amateur drawing with the work of a professional. It is not just a matter of this picture is good and this one is bad. A professional's work demands many things: attention to minute detail, knowledge of the subject matter, the ability to concentrate, and smooth line strokes. Compare your drawings with the following pencil drawings and time how long you take.

Absolute Beginner

Beginner: You've got the perspective right but...

It is more important to get the outline right than draw each strand of hair.

What happened to the sword design? It is not finished yet.

The neck is too far back.

The shoulders are too small and too high.

The gun is one-dimensional and looks like a toy.

The purpose of this belt is not evident.

The hand pose is meaningless.

Unnecessary creases.

When drawing from the head down, there is no room to draw the feet at the bottom of the paper. Start by working out the length of the whole body.

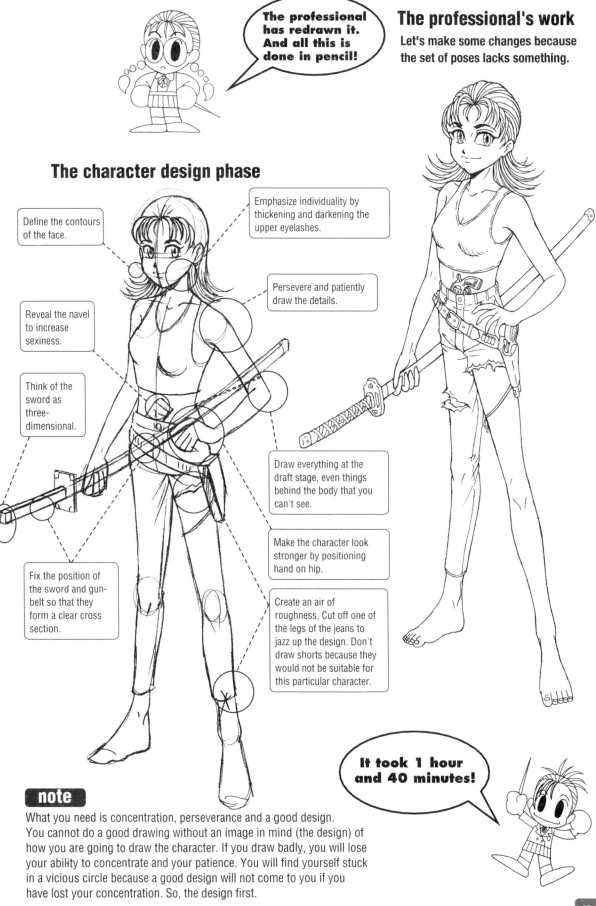

The professional has redrawn it. And all this is done in pencil!

The professional's work

Let's make some changes because the set of poses lacks something.

The character design phase

Define the contours of the face.

Emphasize individuality by thickening and darkening the upper eyelashes.

Persevere and patiently draw the details.

Reveal the navel to increase sexiness.

Think of the sword as three-dimensional.

Fix the position of the sword and gun-belt so that they form a clear cross section.

Draw everything at the draft stage, even things behind the body that you can't see.

Make the character look stronger by positioning hand on hip.

Create an air of roughness. Cut off one of the legs of the jeans to jazz up the design. Don't draw shorts because they would not be suitable for this particular character.

It took 1 hour and 40 minutes!

note

What you need is concentration, perseverance and a good design. You cannot do a good drawing without an image in mind (the design) of how you are going to draw the character. If you draw badly, you will lose your ability to concentrate and your patience. You will find yourself stuck in a vicious circle because a good design will not come to you if you have lost your concentration. So, the design first.

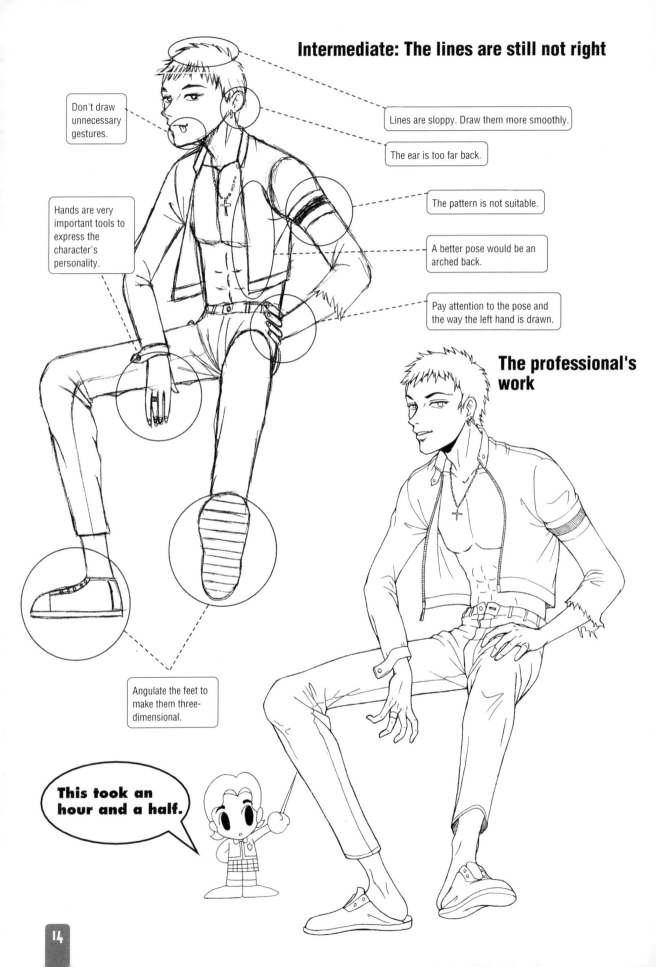

Intermediate: The lines are still not right

Don't draw unnecessary gestures.

Lines are sloppy. Draw them more smoothly.

The ear is too far back.

The pattern is not suitable.

Hands are very important tools to express the character's personality.

A better pose would be an arched back.

Pay attention to the pose and the way the left hand is drawn.

The professional's work

Angulate the feet to make them three-dimensional.

This took an hour and a half.

Advanced: At a glance it looks good but...

Slim down the fingers to make them more feminine.

Pay attention to the position of the hand. Move the hand to one side because it is difficult to see properly if it is over the body.

The accessory design is important but also pay attention to the details.

Express a sense of weight by flattening out the bottom where it is in contact with the ground.

Make eyebrows and eyes symmetrical.

Wavy hair looks softer.

The chin is slightly out.

Vary the thickness of the lines to make the character more three-dimensional.

The legs are slightly too long.

Broaden the feet to give the composition more balance.

The professional's work

This was done in 55 minutes!

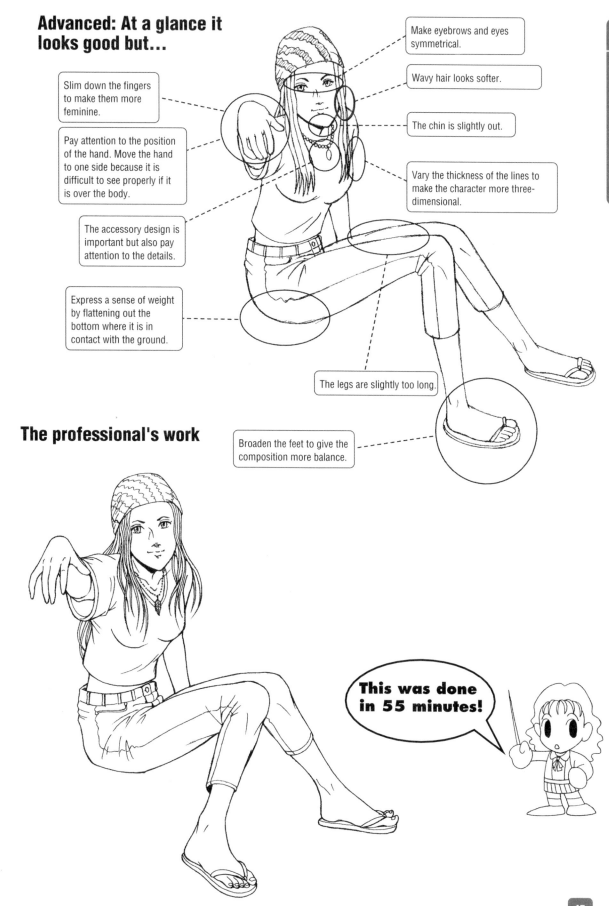

What makes a good picture? The sketch? Careful detail? The design? The theme? The composition? All of these components are important. But **if you want to have your work seen by others**, you must create an impression and communicate your feelings. In other words, you need to be able to communicate in a subliminal way with those who see your work.

> **This is a Graphics test.**

Start by drawing a square box.

1. The frontal view

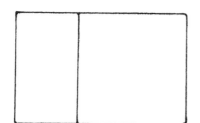

2. The diagonal view

3. A shadow cast on no. 2.

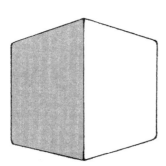

4. In perspective

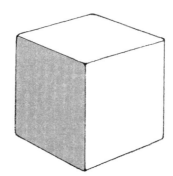

5. A sense of height

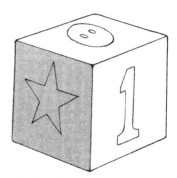

6. A pattern

7. A mechanical pattern

8. One box becomes two

In nos. 1-6, new information is added to the box. Similar to the revised drawings featured on the previous pages, the amount of information contained in the drawings done at the level of an absolute beginner is different to that in advanced work. This is illustrated by the difference between nos. 1 and 8.

The observer (the person who set the task of drawing the boxes) would be expecting only to see what was asked for, that is, a square box. Nos. 6 to 8 **exceed these expectations.** You cannot say that nos. 6 to 8 are mistakes. In fact, each one is an effective clue that shows individualistic interpretation.

It is invaluable to give the drawing **an element of surprise** and incorporate extra information into it that would make it more interesting. Of course, to do this you need to be able to sketch. But on top of that, you must also come up with an ingenious theme, character pose and design.

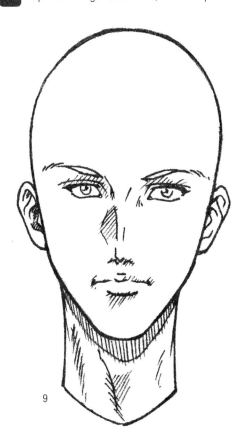

9

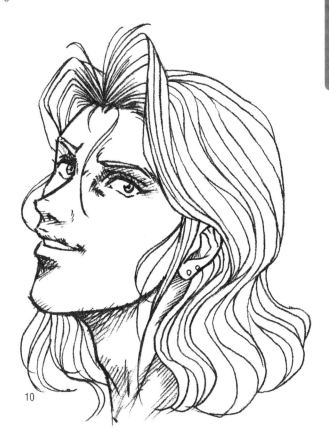

10

Although the character in nos. 9 and 10 is one and the same, you can see how they differ not only in design but also in personality. **It is a subconscious prerequisite in the reader's mind** for main anime and manga characters to be attractive. **It is what is expected**. By adding depth to their attractiveness, **we can surprise the reader by surpassing their expectations**. It marks the first step when someone says your drawing is "good," but a real beginning when they say it is "great."

You can also **draw in accordance with reader's expectations** like in the coterie magazines.
 For instance, looking at the boxes on the previous page, although the animator can draw up to level 8, he or she doesn't because readers are expecting to see a level-6 drawing. Similarly, an animator, instead of drawing a realistic illustration, draws manga with simple strokes and creates
suitable characters such as the **Simple deformed(SD) Character**.

Are you talking about me?

If you can hold a pen and draw straight lines in pencil, you will be able to draw.

Practice drawing the 8 boxes (cubes) on the next page freehand. These boxes are drawn freehand without thinking about perspective and the vanishing point. Up close, they may look a little strange. But they pass for three-dimensional shapes.

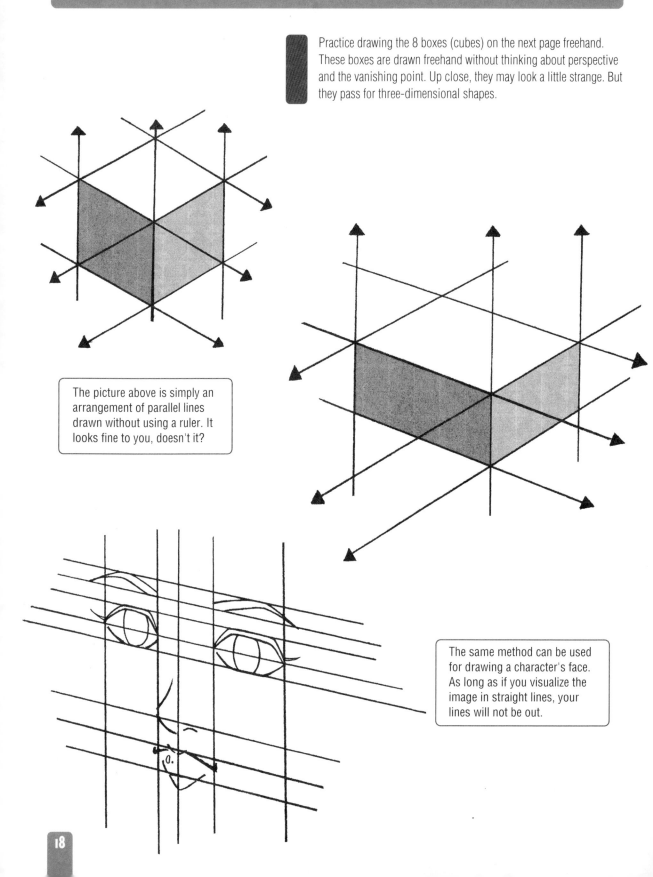

The picture above is simply an arrangement of parallel lines drawn without using a ruler. It looks fine to you, doesn't it?

The same method can be used for drawing a character's face. As long as if you visualize the image in straight lines, your lines will not be out.

1·5

If you can hold a pen and draw straight lines in pencil, you will be able to draw.

First of all, draw the square boxes.

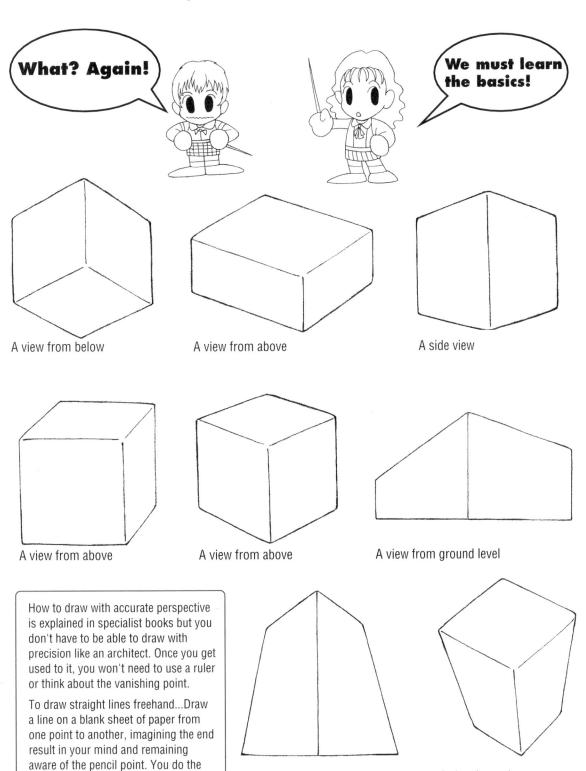

What? Again!

We must learn the basics!

A view from below

A view from above

A side view

A view from above

A view from above

A view from ground level

How to draw with accurate perspective is explained in specialist books but you don't have to be able to draw with precision like an architect. Once you get used to it, you won't need to use a ruler or think about the vanishing point.

To draw straight lines freehand...Draw a line on a blank sheet of paper from one point to another, imagining the end result in your mind and remaining aware of the pencil point. You do the same with your sketches, just on a larger scale.

A view from ground level

A view from above

Start drawing for real! But before that...

It's OK saying you'll start drawing, but what are you going to draw?
Do you get hold of the pencil willy-nilly? Are you going to draw a RPG (Role Playing Game) Character? A manga character? A character in a fight? Or, are you planning to draw an illustration or a poster? Charts of characters' Basic Expressions? It doesn't matter if what you draw is a scribble. Only, **make sure you have a concrete image** of the character, the scene and the pose. Good pictures start with character design.

Once this is decided, you draw the outline of the movement to create a general image. **You don't have to worry about drawing the hands over and over again or if there is enough room for feet on the page**. A good picture has a solid outline. This is the first step in **a sketch**.

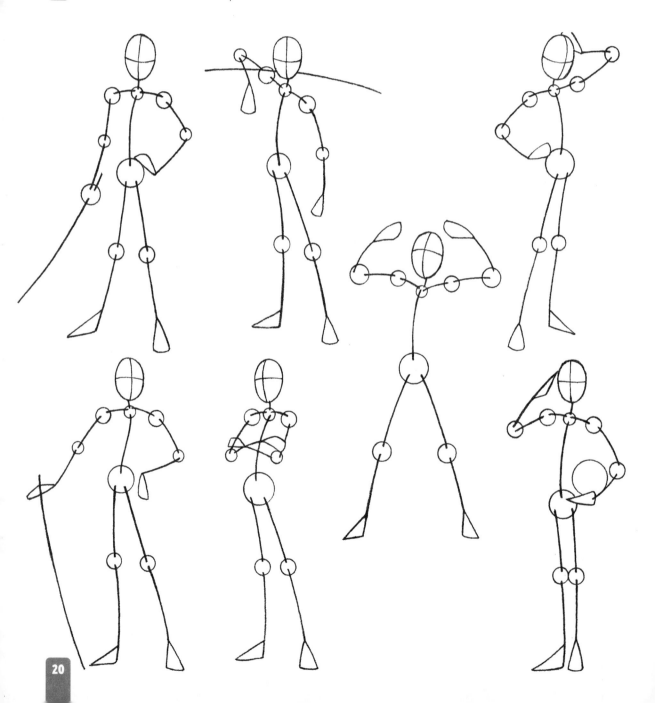

Several poses are shown below. Pay particular attention to **the bending of the backbone**. The human body is quite flexible and the backbone is curved even in a standing position.

A character's individuality is evident even without such details as hairstyle, eyes and creases in clothes. Your job is not simply **to decide** the pose. It is also to direct and thereby incorporate more information about the character into the drawing. **This is subliminal information**.

For those of you with doubts on your ability to draw, take a look at the sketches below. When It comes to using only lines and circles, it is not really a matter of making judgements about skill levels. But these sketches do actually decide about 40% of what makes a good drawing.

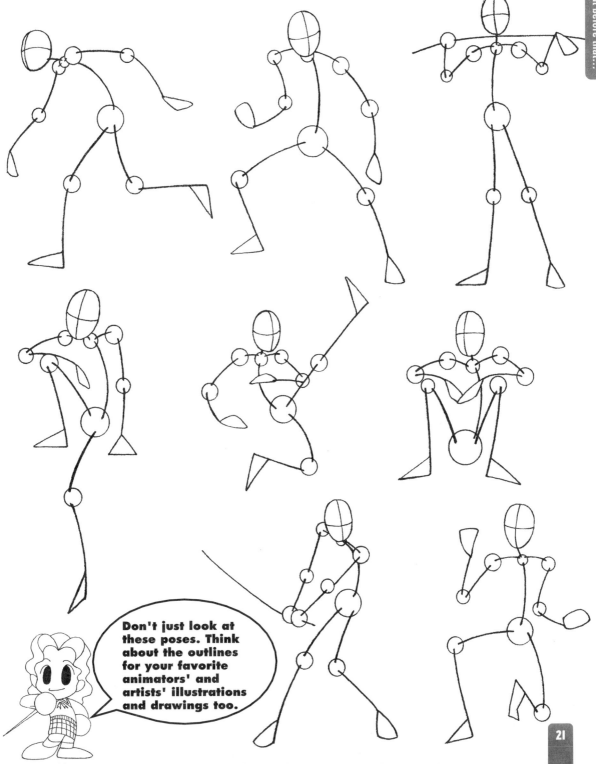

Don't just look at these poses. Think about the outlines for your favorite animators' and artists' illustrations and drawings too.

Now flesh out the outline!

 Generally, people think that getting the balance right in a sketch is hard. But it isn't really. Think of the simplest polygon. When you are drawing an illustration, you don't have to draw a square. However, you must decide which direction each part of the body is facing. And once you have got this you will be fine.

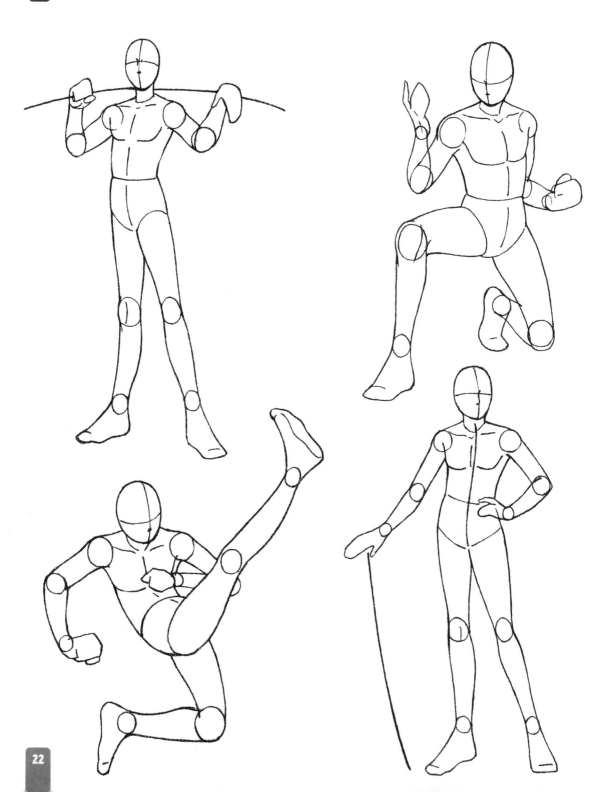

As long as you can draw square boxes, you will be able to draw characters.

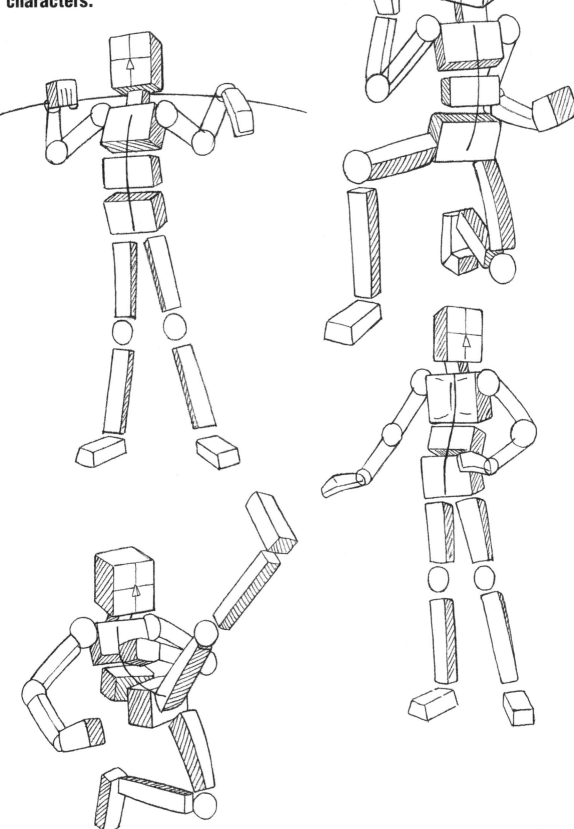

Which of the six types shown below appeals to you the most?
The OVA (Original Video Anime) ? Manga? Illustrative? You may have tried to imitate the style of your favorite manga artist or animator, but it just doesn't look the same.

So far, the characters you have sketched differ in body proportions and design to the characters you like.
We don't have to analyze the body proportion of characters in great detail. All I ask is that you are aware of which type/s you want to draw.

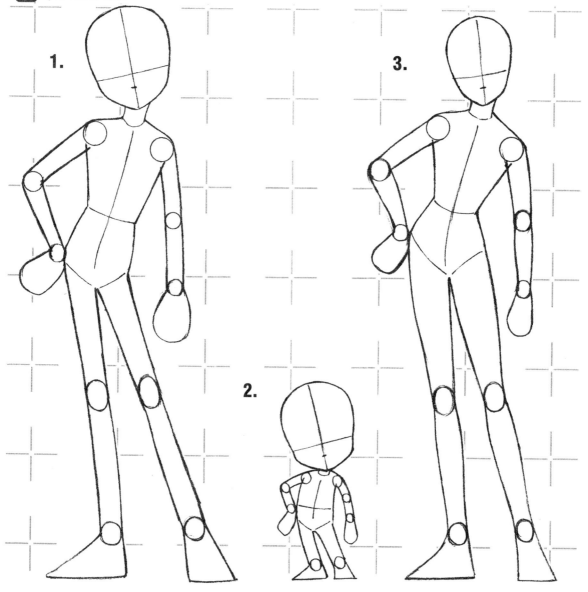

1.

3.

2.

1. Comical Animation Character
Large head, hands and feet. Not much definition of joints and muscles. Limbs look small compared with the head.

2. SD Character
A small body with a large head. Not particularly comical or cute.

3. Bishoujo (Young, pretty girl)
A thin waist and slight definition of body contours. Joints and muscles are defined.

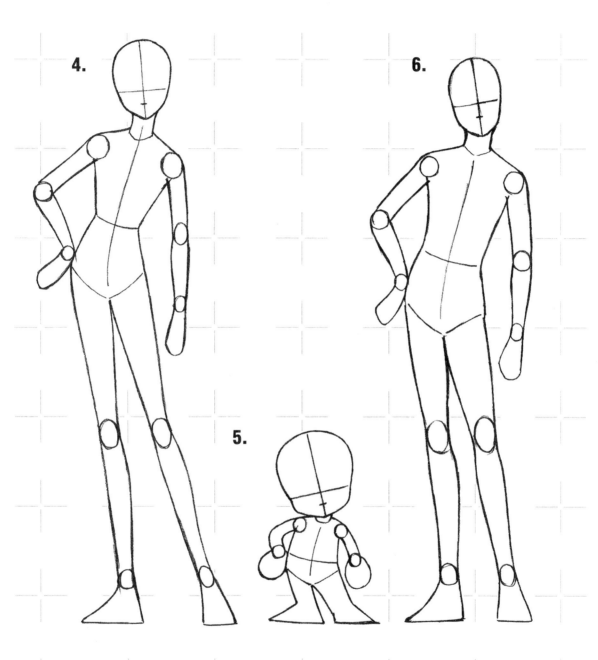

4.

6.

5.

4. Shoujo Manga (Gal's Comics) character
Overall very thin with long legs. For girls, body contours are defined but the head is small. Boys are drawn almost the same but with broader shoulders.

5. Comical SD Character
Unlike the SD Character on the previous page, this type looks funny with thin arms but big hands, legs and feet.

6. Real Type
The length of the body torso and legs are roughly the same. Girls do not have exaggerated narrow waists.

It is time to think about body proportions now.

Character drawing differs with the subject. It is not simply about body proportion. Depending on whether it is manga or an illustration, for example, the same character will have very different features. Compare the different drawings of the same character below, especially looking at the ways the eyes and hands have been drawn. Do you notice how some features have been drawn in detail while others have been omitted.

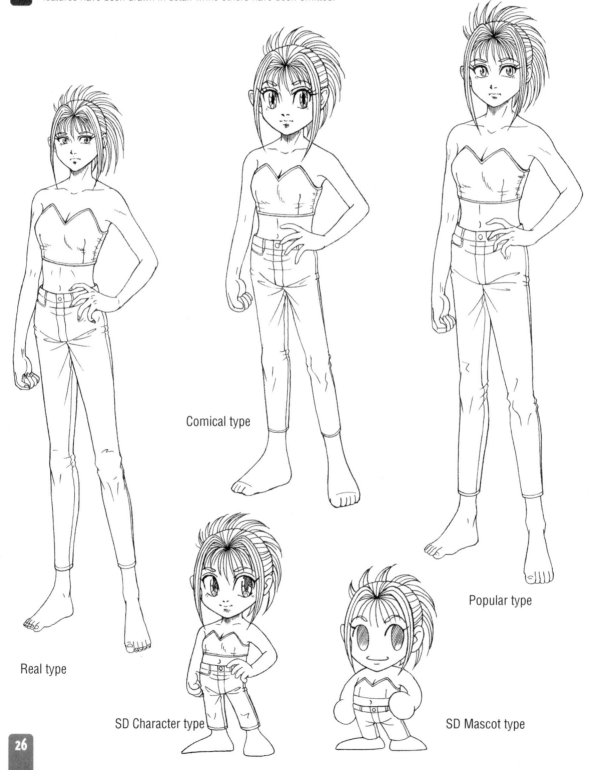

Comical type

Popular type

Real type

SD Character type

SD Mascot type

Chapter 2
Different Ways
to Draw Characters' Expressions

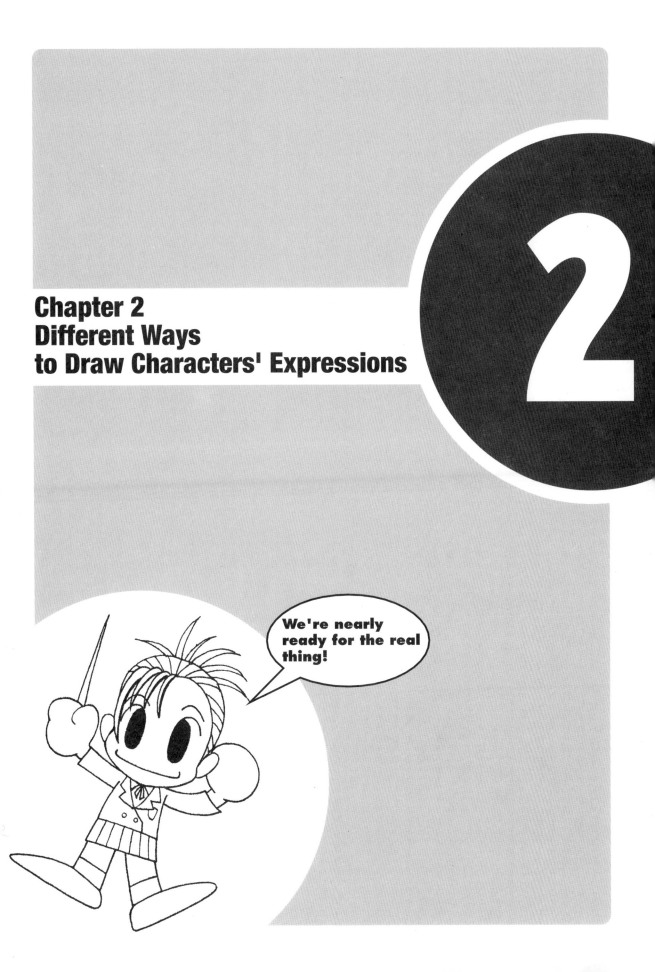

We're nearly ready for the real thing!

Have you ever looked at a drawing you've done through the back of the paper?

You can easily see **distortions in a sketch** if you do. Especially those faces looking straight out.

These distortions come about when you are preoccupied with flat outlines and not not thinking in 3-D..

What can be done about it? The answer is **think polygons**. The drawing below, a common one in video games, is like a piece of sculpture, isn't it? You don't have to be able to draw it. What's more important is that you acquire a feel for it. It is very abstract. But **the feeling is important**. If you have this, your drawings will have the power to move people.

Think back to the square boxes in Chapter 1. They are the simplest polygons. Next, we will take a look at how characters' bodies can be made up of polygons.

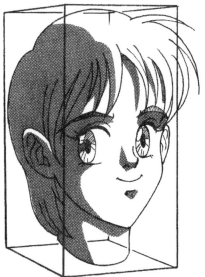

The completed drawing: The professional's work

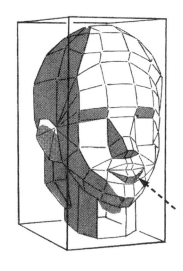

This is the first stage. Take care when drawing the mouth. The lips jut out but are not curved. So it looks as if they are just stuck on.

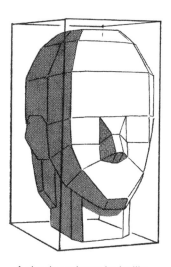

A simpler polygon looks like this.

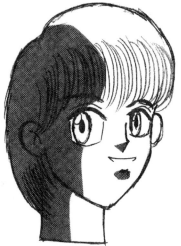

You can't put your finger on it but something is wrong with this drawing.

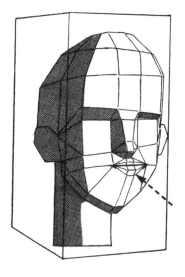

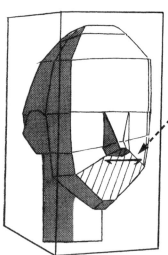

The drawing went wrong at the initial stage. Look at the eyes. First, look at the size of them. The left and right eyes are slightly different. Then, look at where they are. **The position of the eyes is off** and this is the most common reason for a picture looking odd. The height of the eyes is unnatural because they are not aligned parallel with the inclination of the face (the outline of the head). It would be the same curved. Look at the completed drawing below.

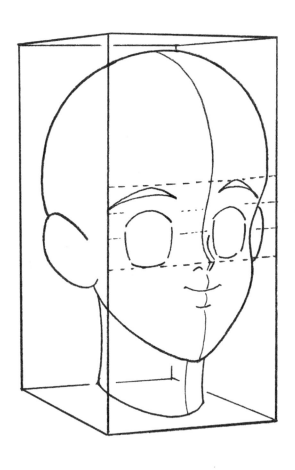

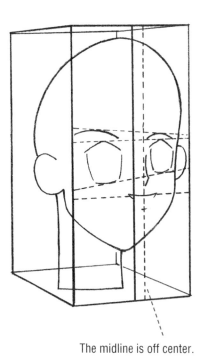

The midline is off center.

The eyes are not the same height. The cross-lines on the face are at completely different angles.

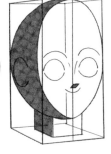

The lines for the height of the eyes should be parallel. The cross-lines on the face should cross the midline at right angles.

note

It is basically the same for exaggerated Anime characters as well. When you can draw faces as cubes without having to think about it, you know that you have improved a great deal.

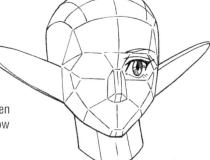

As explained on the previous page, when drawing the face, the most important line that you draw is the cross-line. It is the first one you draw and decides position and direction. Drawing the features, the eyes and the hairstyle may be more fun but it is the cross-lines that decide the character design. So, pick up a pencil and have a go at drawing the real thing.

Real Type Character

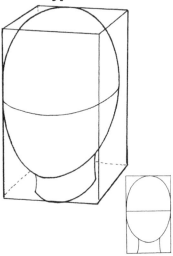

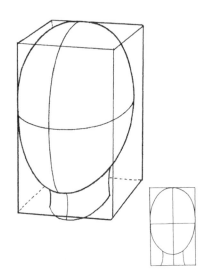

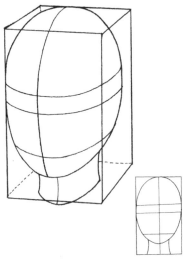

1. First of all, the horizontal cross-line decides the height of the eyes.

2. Next, the midline is drawn vertically on the full face. This line marks the bridge of the nose.

3. Then, the horizontal lines that decide the positions of the mouth and eyebrows are drawn. The distance between these two lines decides the size of the eyes. The knack when drawing the character below is to draw these lines wide apart so that the eyes are big.

Exaggerated Type Character

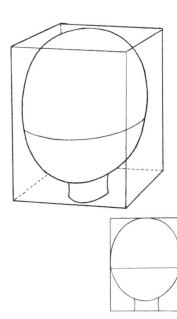

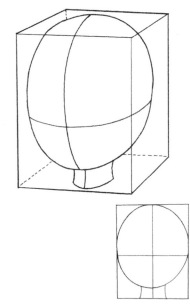

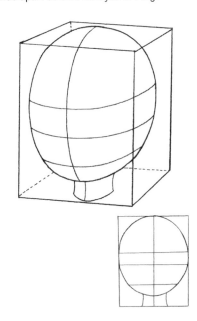

2-2

Drawing For Real! Parts of the Face and Position

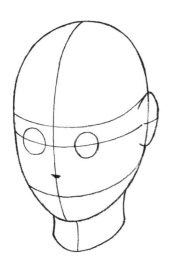

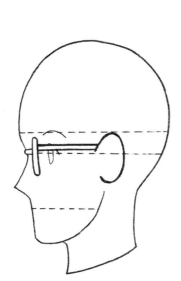

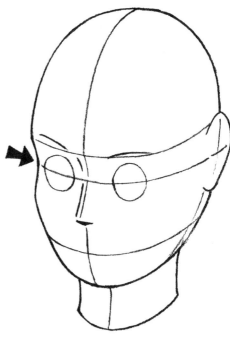

4. The position for the nostrils is marked on the line for the bridge of the nose. The eyes are drawn on this line and their size roughly estimated. The general rule is that the lower the position of the eyes, the more childish the face (See the drawing below).

5. Above the line that decides the height of the eyes draw another line to decide the size of the ears. The height of the ears is about where the frame of a pair of glasses would sit. Normally the position for the corner of the eyes is about where the root of the ear is. But the more you get used to it, the more you can play around with the positioning to make more exaggerated characters.

6. The outline between the eyebrow line and the eye line hollows out. This makes the depressions for the eyes. Mistakes are often made at this point. Even those people who are fairly good at drawing end up drawing the base of the nose from the eye line. Have a look at the bridge of your nose in the mirror. See how it starts between the eyebrows, depresses in between the eyes, and then sticks out.

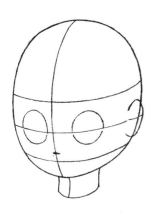

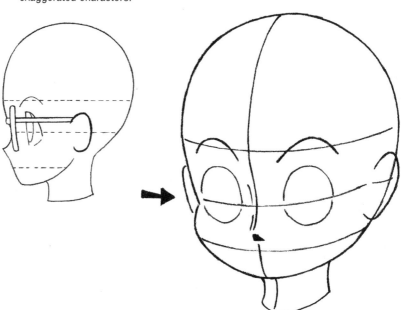

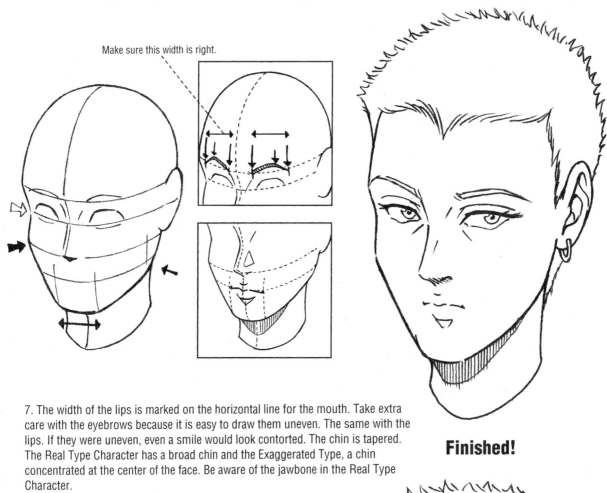

Make sure this width is right.

7. The width of the lips is marked on the horizontal line for the mouth. Take extra care with the eyebrows because it is easy to draw them uneven. The same with the lips. If they were uneven, even a smile would look contorted. The chin is tapered. The Real Type Character has a broad chin and the Exaggerated Type, a chin concentrated at the center of the face. Be aware of the jawbone in the Real Type Character.

Finished!

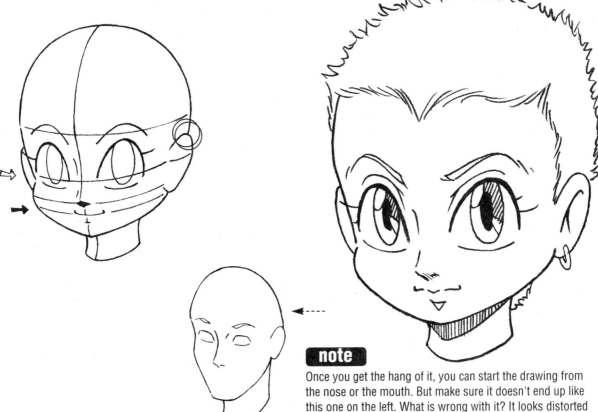

note

Once you get the hang of it, you can start the drawing from the nose or the mouth. But make sure it doesn't end up like this one on the left. What is wrong with it? It looks distorted because the head is too small.

Exaggerated Type

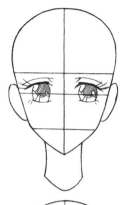

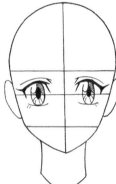

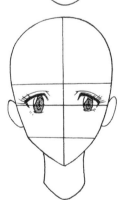

Don't be taken in by the hairstyle!

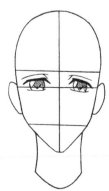

Simple Type

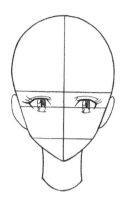

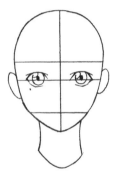

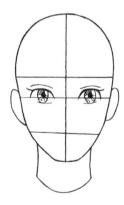

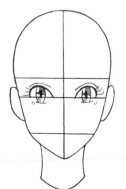

Real Type

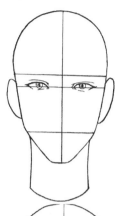

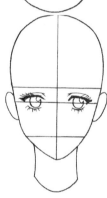

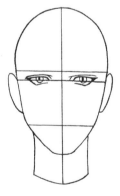

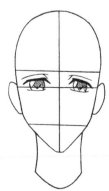

33

In a real story, you have to be able to draw not just faces in profile but faces in all sorts of positions such as looking up and down. The following views are drawn with the cross-line.

Below we have the basic set of head positions for the characters featured in this book. Once you can draw these, you can probably create your own work.

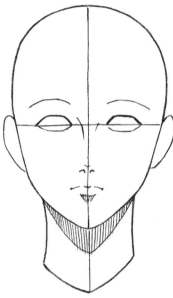

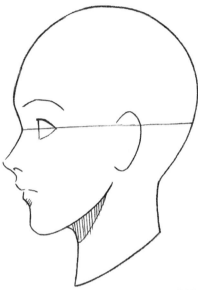

Basic 1 (Frontal): Level of difficulty 1

Asymmetry is most obvious in this position. The width to the left and right of the vertical midline must be the same.

Basic 2 (Profile): Level of difficulty 1

The knack is to distance the base of the nose and eyeballs further apart than you would first think. Take into consideration the height of the nose between the eyes. The bottom lip protrudes less than the top.

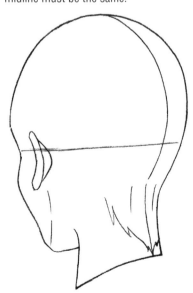

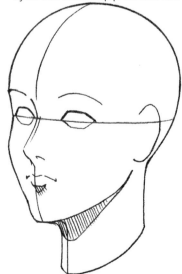

Oblique from behind: Level of difficulty 3

Don't forget the thickness of the ears. Make sure the horizontal eye-line remains level.

Oblique left: Level of difficulty 2

Even though this is one that people can draw, it is also easy to get the perspective out. Pay attention to the size of the eyes.

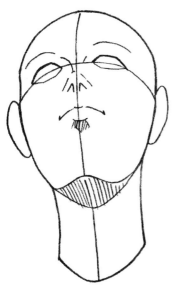

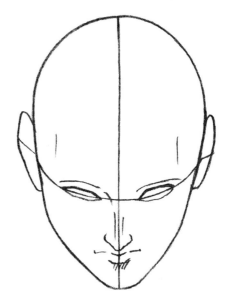

From below: Level of difficulty 5

Pay attention to the line from the tip of the chin to the eyes. The position of the nostrils is higher than you would first think.

From above: Level of difficulty 5

The positions for the top of the nose and the mouth are almost exactly the same. The angle of the eyebrows changes the down-looking position of the head. Refer to this position for each character in the pages to follow.

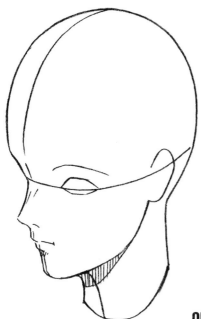

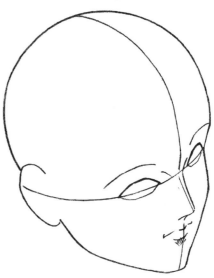

Oblique left and right + From slightly above: Level of difficulty 3

Take care with the size of the head. People tend to draw the ears and the nose too close together. The drawing will be unbalanced if the head isn't thick enough.

The scale of difficulty is 1 to 5.

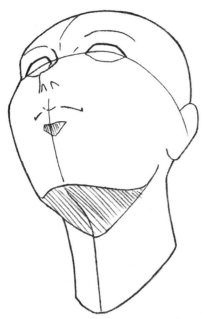

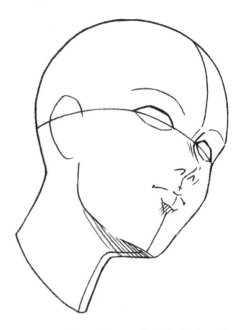

Oblique left + From below: Level of difficulty 5

Once you can draw this, you can improve the variation in your drawings dramatically. This angle must be practiced because it is commonly used. Make the curves of the eyes and the head parallel so that the eyes don't droop. Take care where you draw the hairline because it differs depending on the character.

Oblique right + From slightly below: Level of difficulty 4

The inclination of the eyes is difficult to get right. Make the chin and forehead parallel. Do the same with the eyebrows and eyes.

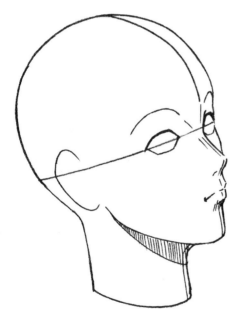

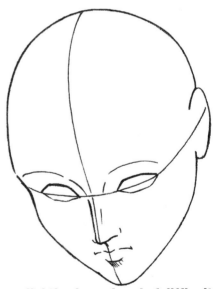

Oblique right: Level of difficulty 4

This angle often appears in interview tests at animation studio companies. How the parts on the other side of the nose-line (the cheeks, eyes, eyelids and eyebrows) are drawn is very important. It is a good indication of your drawing ability. Pay attention to the distance between the eyes and ears.

From slightly above: Level of difficulty 2

This is at an angle so it is not exactly a full view from above. Nevertheless the nose and mouth are drawn close to each other. Right-handers generally tend to have difficulty in drawing this position properly.

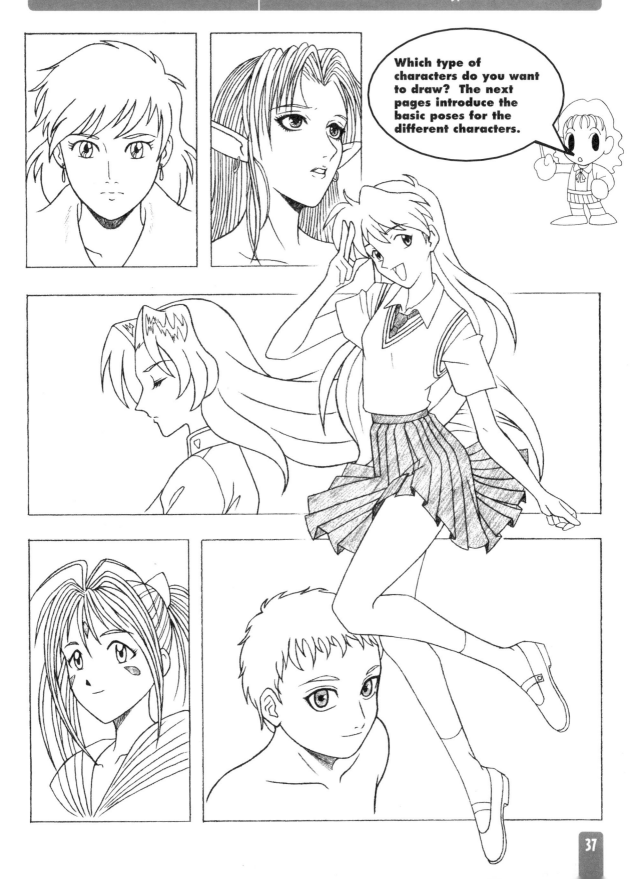

Which type of characters do you want to draw? The next pages introduce the basic poses for the different characters.

Characters' Expressions by Type/ Head Exaggerated Type A/Girl

This character is **a mix between Takarazuka (an all-women theatrical company in Japan) and Gakuen (School Life) genres**. Her traits are the **exaggerated hairstyle and eyes**. Once you have mastered these two characteristics, you should have no problem drawing this type of character. Take care with her glossy hair, highlighted lips and liquid eyes.

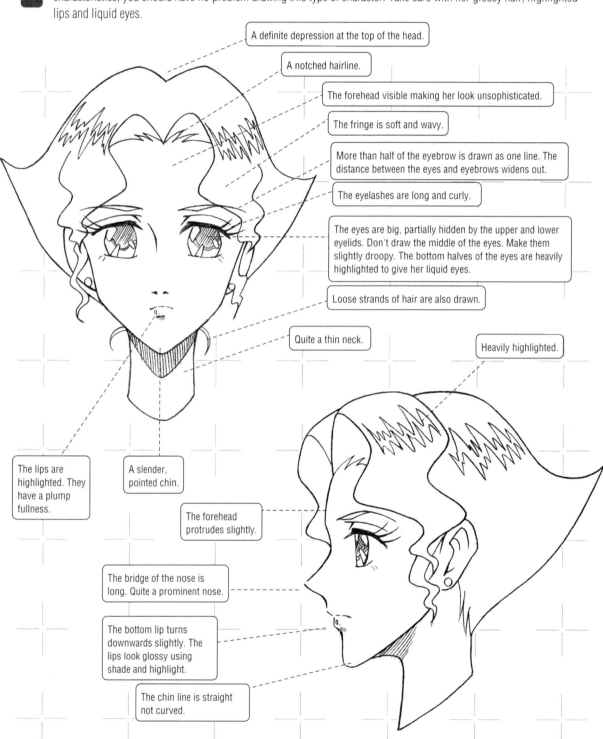

A definite depression at the top of the head.

A notched hairline.

The forehead visible making her look unsophisticated.

The fringe is soft and wavy.

More than half of the eyebrow is drawn as one line. The distance between the eyes and eyebrows widens out.

The eyelashes are long and curly.

The eyes are big, partially hidden by the upper and lower eyelids. Don't draw the middle of the eyes. Make them slightly droopy. The bottom halves of the eyes are heavily highlighted to give her liquid eyes.

Loose strands of hair are also drawn.

Quite a thin neck.

Heavily highlighted.

The lips are highlighted. They have a plump fullness.

A slender, pointed chin.

The forehead protrudes slightly.

The bridge of the nose is long. Quite a prominent nose.

The bottom lip turns downwards slightly. The lips look glossy using shade and highlight.

The chin line is straight not curved.

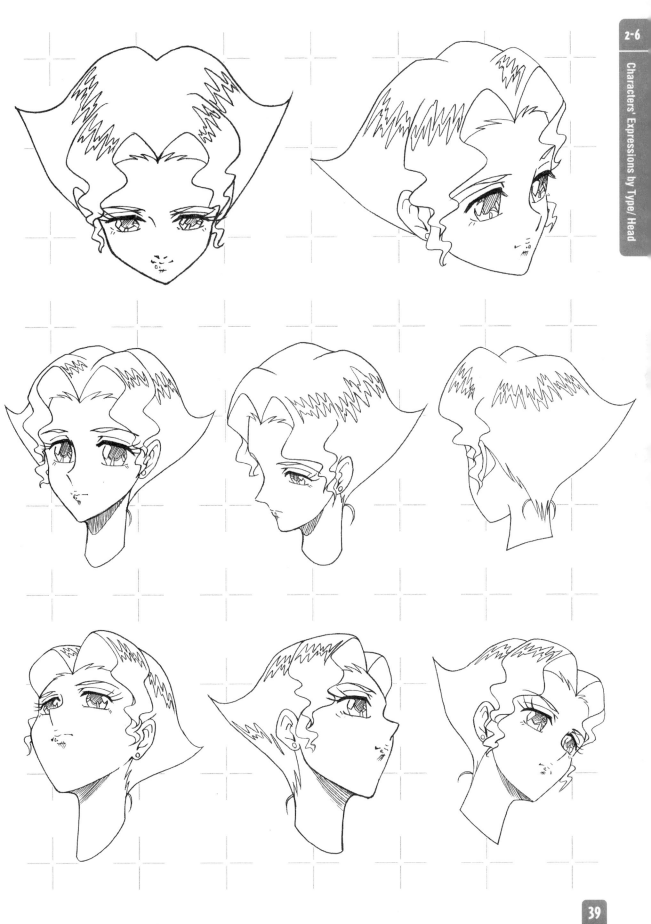

Characters' Expressions by Type/ Head Exaggerated Type A/Boy

His personality differs depending on the story. He is **flashy and tries to be cool** but most of the time he has a comic role. His **droopy eyes** are evidence of this. He is often up to something devious but his plans usually backfire. He's a character that you cannot help but like though. He always falls for the leading heroine.

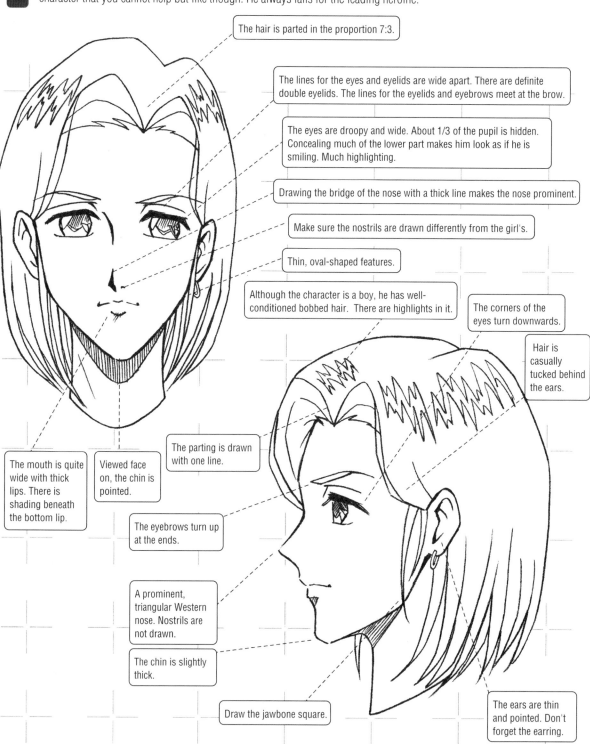

The hair is parted in the proportion 7:3.

The lines for the eyes and eyelids are wide apart. There are definite double eyelids. The lines for the eyelids and eyebrows meet at the brow.

The eyes are droopy and wide. About 1/3 of the pupil is hidden. Concealing much of the lower part makes him look as if he is smiling. Much highlighting.

Drawing the bridge of the nose with a thick line makes the nose prominent.

Make sure the nostrils are drawn differently from the girl's.

Thin, oval-shaped features.

Although the character is a boy, he has well-conditioned bobbed hair. There are highlights in it.

The corners of the eyes turn downwards.

Hair is casually tucked behind the ears.

The parting is drawn with one line.

The mouth is quite wide with thick lips. There is shading beneath the bottom lip.

Viewed face on, the chin is pointed.

The eyebrows turn up at the ends.

A prominent, triangular Western nose. Nostrils are not drawn.

The chin is slightly thick.

Draw the jawbone square.

The ears are thin and pointed. Don't forget the earring.

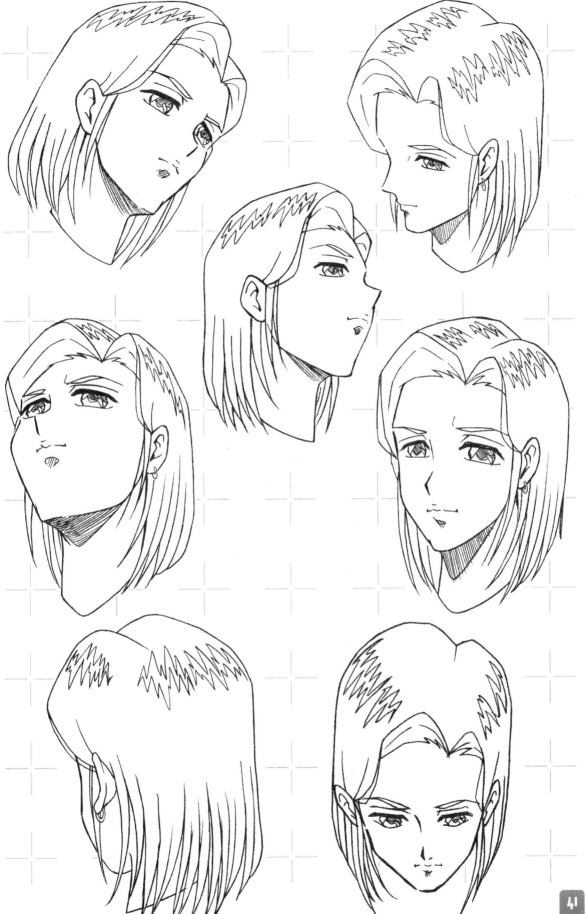

Characters' Expressions by Type/ Head **Exaggerated type B/Girl**

 She is naturally friendly and in most scenes she is smiling. Draw her with droopy eyes to express her cheerful, gentle personality. Her hairstyle is exaggerated because she is a Fantasy Genre Character. Don't waste time trying to figure out why she has this hairstyle. Just accept it as on of her trait.

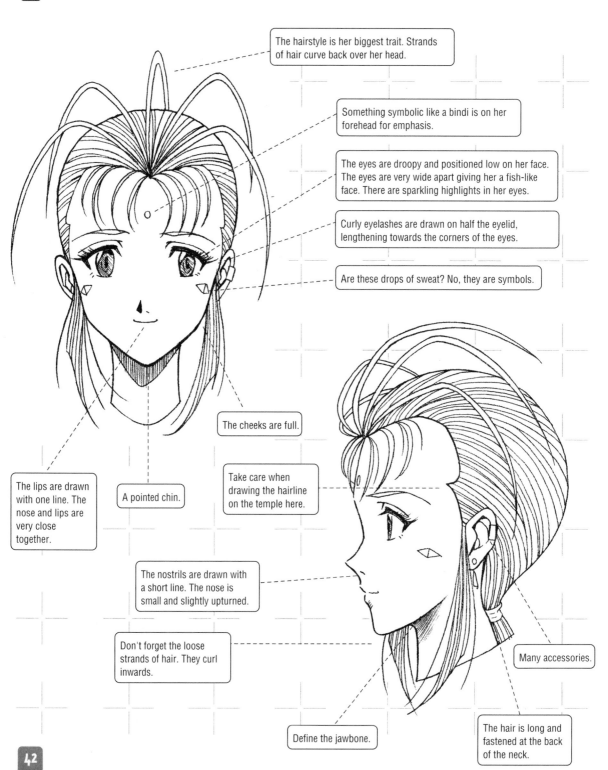

The hairstyle is her biggest trait. Strands of hair curve back over her head.

Something symbolic like a bindi is on her forehead for emphasis.

The eyes are droopy and positioned low on her face. The eyes are very wide apart giving her a fish-like face. There are sparkling highlights in her eyes.

Curly eyelashes are drawn on half the eyelid, lengthening towards the corners of the eyes.

Are these drops of sweat? No, they are symbols.

The cheeks are full.

Take care when drawing the hairline on the temple here.

The lips are drawn with one line. The nose and lips are very close together.

A pointed chin.

The nostrils are drawn with a short line. The nose is small and slightly upturned.

Don't forget the loose strands of hair. They curl inwards.

Many accessories.

Define the jawbone.

The hair is long and fastened at the back of the neck.

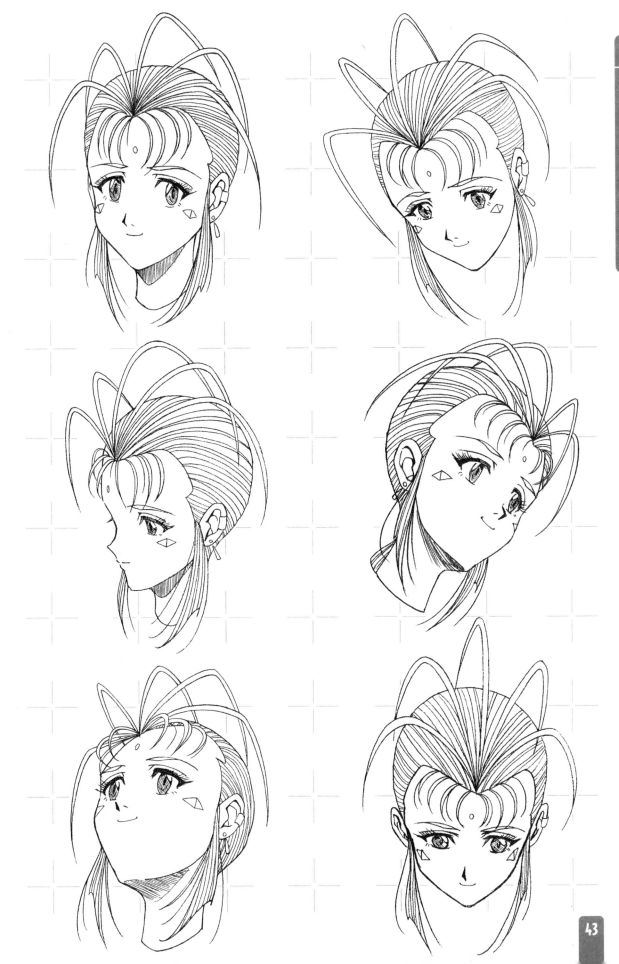

Characters' Expressions by Type/ Head Exaggerated Type B/Boy

A cool Bishounen (Young, attractive boy). He has hidden subtlety and coldness. Express his androgynous beauty with a flouncy fringe and glossy hair. Like the girl, he has a symbol decorating his forehead. With his eyes positioned low, he has the look of a young boy about him. But he is maturer than his appearance suggests.

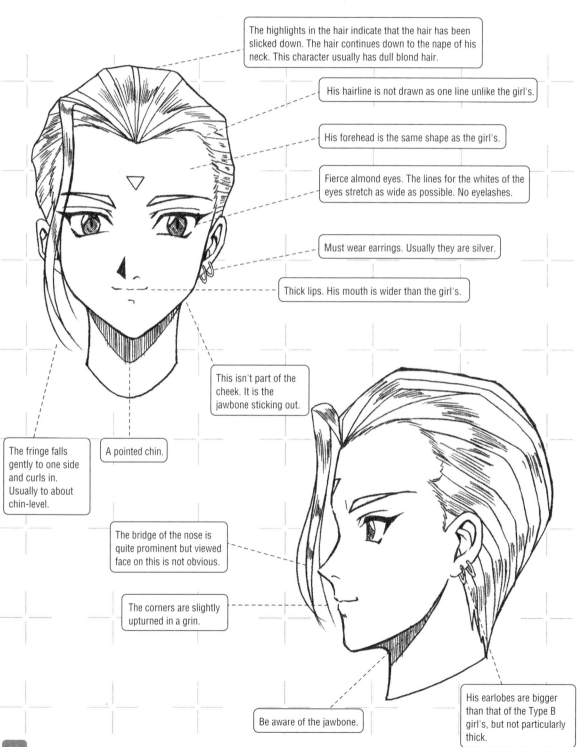

The highlights in the hair indicate that the hair has been slicked down. The hair continues down to the nape of his neck. This character usually has dull blond hair.

His hairline is not drawn as one line unlike the girl's.

His forehead is the same shape as the girl's.

Fierce almond eyes. The lines for the whites of the eyes stretch as wide as possible. No eyelashes.

Must wear earrings. Usually they are silver.

Thick lips. His mouth is wider than the girl's.

This isn't part of the cheek. It is the jawbone sticking out.

The fringe falls gently to one side and curls in. Usually to about chin-level.

A pointed chin.

The bridge of the nose is quite prominent but viewed face on this is not obvious.

The corners are slightly upturned in a grin.

His earlobes are bigger than that of the Type B girl's, but not particularly thick.

Be aware of the jawbone.

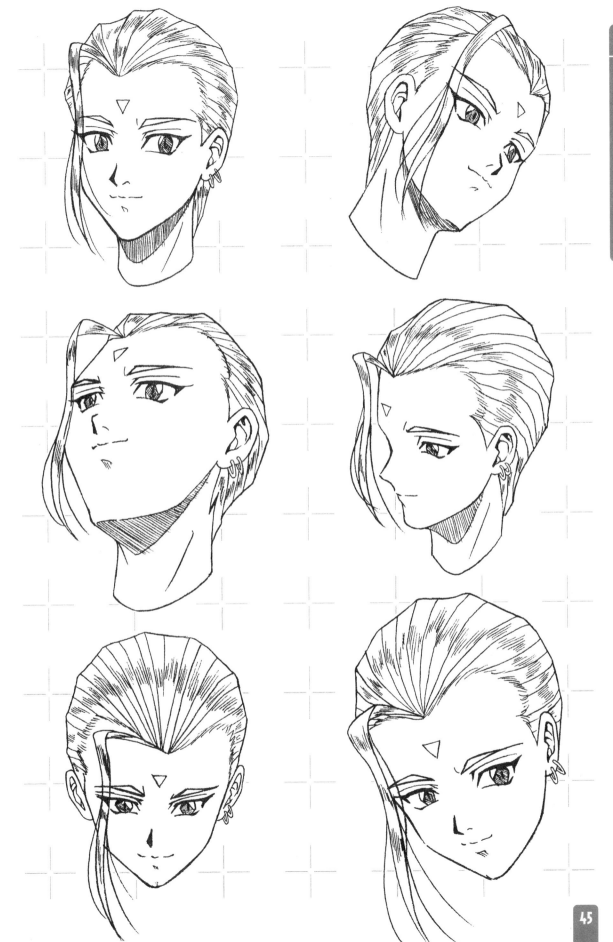

Characters' Expressions by Type/ Head **Exaggerated Type C/Girl**

 A lively, energetic girl. She often plays the role of childhood playmate to the hero. She is courageous and never gives up. This character has exaggerated eyes. Take care to get the size and height of eyes right especially face on.

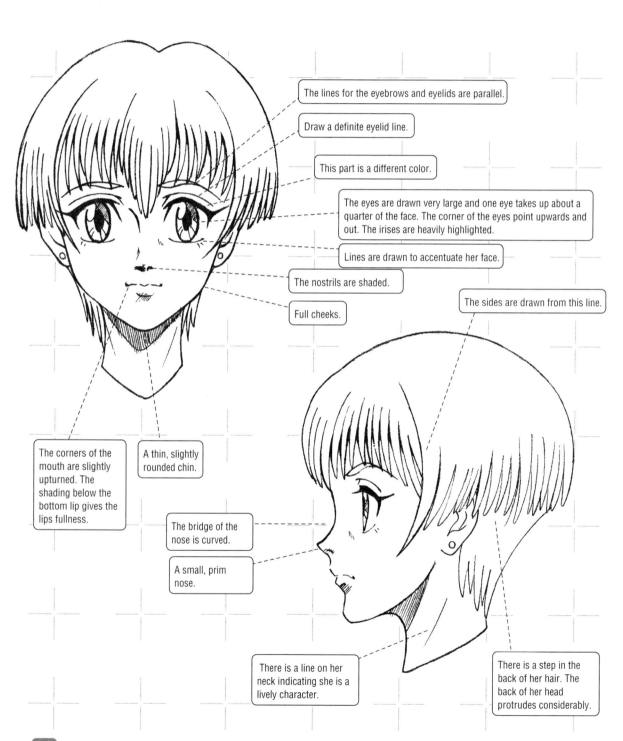

The lines for the eyebrows and eyelids are parallel.

Draw a definite eyelid line.

This part is a different color.

The eyes are drawn very large and one eye takes up about a quarter of the face. The corner of the eyes point upwards and out. The irises are heavily highlighted.

Lines are drawn to accentuate her face.

The nostrils are shaded.

Full cheeks.

The sides are drawn from this line.

The corners of the mouth are slightly upturned. The shading below the bottom lip gives the lips fullness.

A thin, slightly rounded chin.

The bridge of the nose is curved.

A small, prim nose.

There is a line on her neck indicating she is a lively character.

There is a step in the back of her hair. The back of her head protrudes considerably.

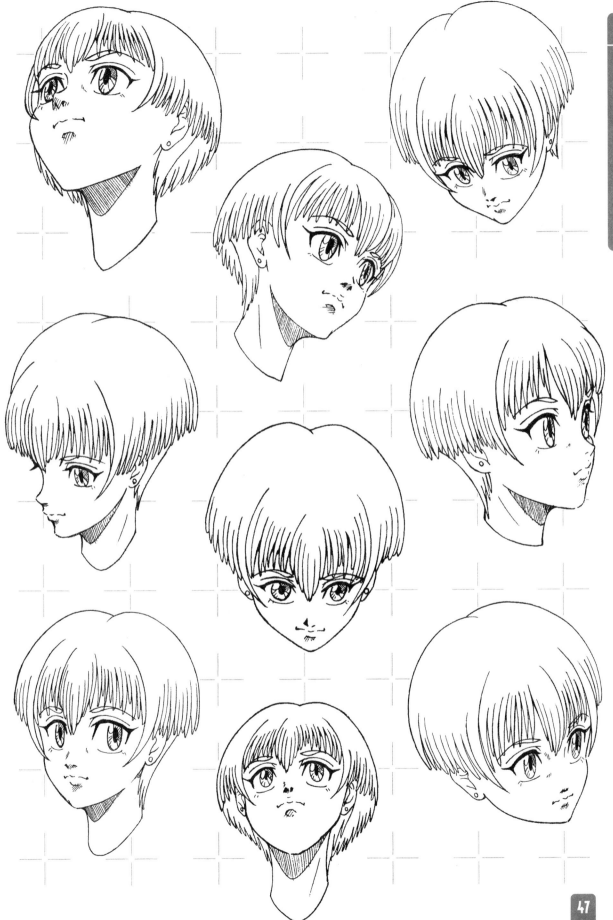

 Out of all the boys featured in this book, this character has the roundest face. Like the girl, he is lively and cheerful. His energy is expressed in his large upturned mouth and sparkling eyes. He is quite mischievous.

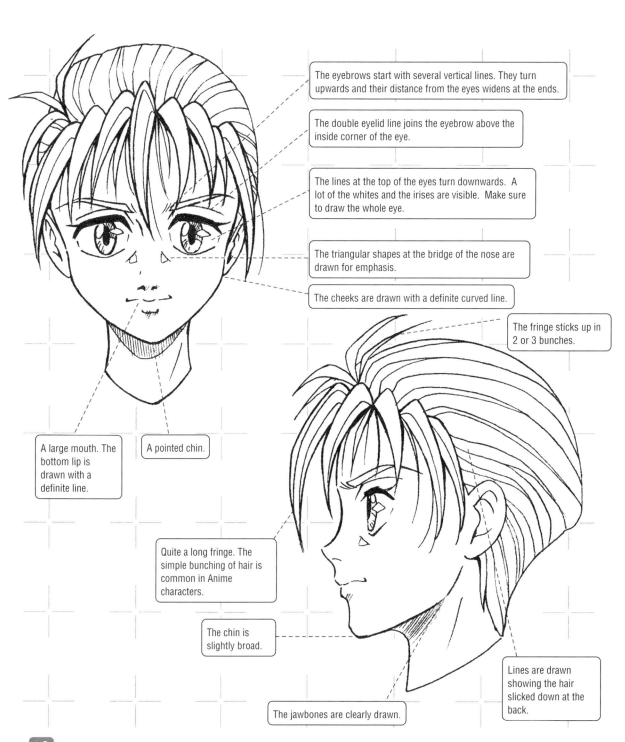

The eyebrows start with several vertical lines. They turn upwards and their distance from the eyes widens at the ends.

The double eyelid line joins the eyebrow above the inside corner of the eye.

The lines at the top of the eyes turn downwards. A lot of the whites and the irises are visible. Make sure to draw the whole eye.

The triangular shapes at the bridge of the nose are drawn for emphasis.

The cheeks are drawn with a definite curved line.

The fringe sticks up in 2 or 3 bunches.

A large mouth. The bottom lip is drawn with a definite line.

A pointed chin.

Quite a long fringe. The simple bunching of hair is common in Anime characters.

The chin is slightly broad.

Lines are drawn showing the hair slicked down at the back.

The jawbones are clearly drawn.

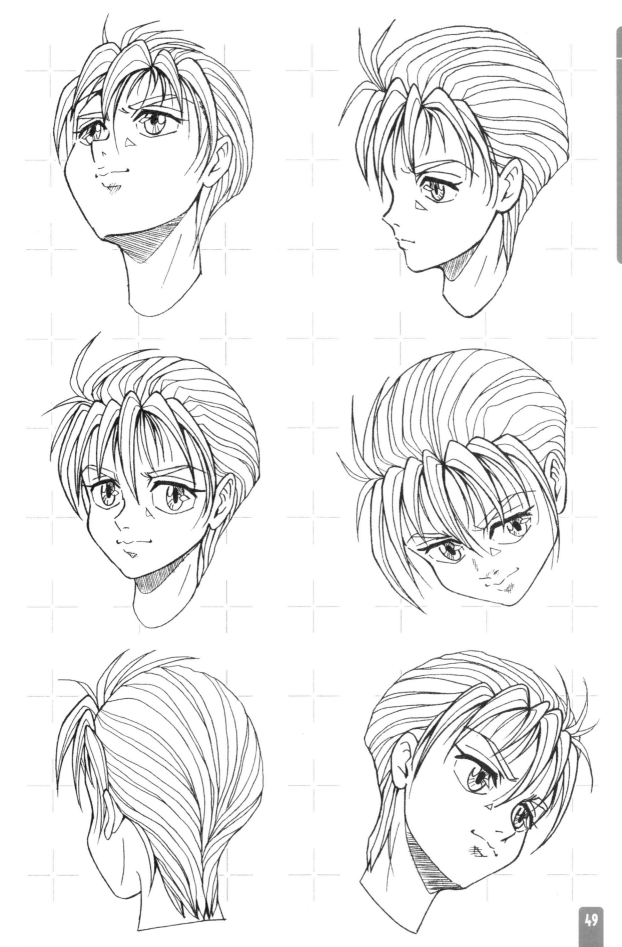

Characters' Expressions by Type/ Head **Simple Type A/Girl**

Androgynous, boyish and energetic. A diplomatically cheerful group leader. Draw her with nicely varied clear lines. She often wears simple accessories that are connected to the story line in some way rather than as decoration. The lines for the upper eyelids, eyebrows and chin are drawn in thick strong curves to express her liveliness. Her girlish femininity is expressed in a natural way in the thinness of her chin and neck, the absence of the jawbone and the lines drawn beneath the eyes.

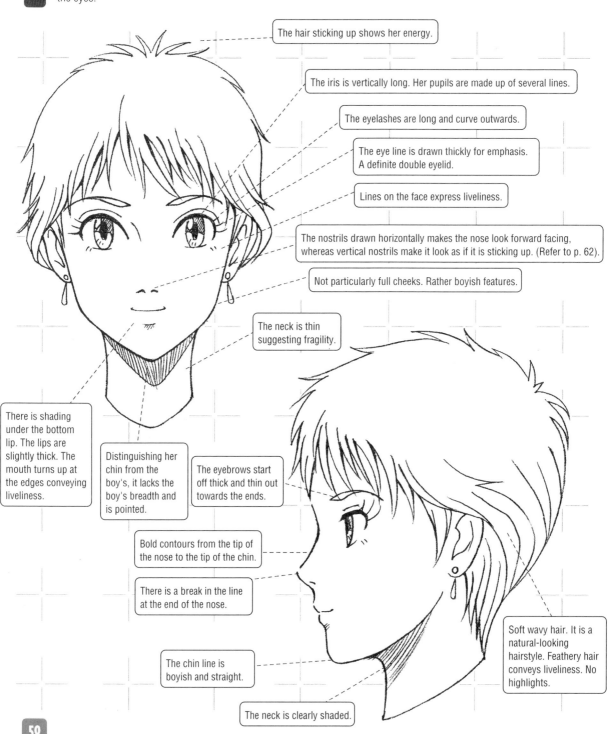

The hair sticking up shows her energy.

The iris is vertically long. Her pupils are made up of several lines.

The eyelashes are long and curve outwards.

The eye line is drawn thickly for emphasis. A definite double eyelid.

Lines on the face express liveliness.

The nostrils drawn horizontally makes the nose look forward facing, whereas vertical nostrils make it look as if it is sticking up. (Refer to p. 62).

Not particularly full cheeks. Rather boyish features.

The neck is thin suggesting fragility.

There is shading under the bottom lip. The lips are slightly thick. The mouth turns up at the edges conveying liveliness.

Distinguishing her chin from the boy's, it lacks the boy's breadth and is pointed.

The eyebrows start off thick and thin out towards the ends.

Bold contours from the tip of the nose to the tip of the chin.

There is a break in the line at the end of the nose.

The chin line is boyish and straight.

Soft wavy hair. It is a natural-looking hairstyle. Feathery hair conveys liveliness. No highlights.

The neck is clearly shaded.

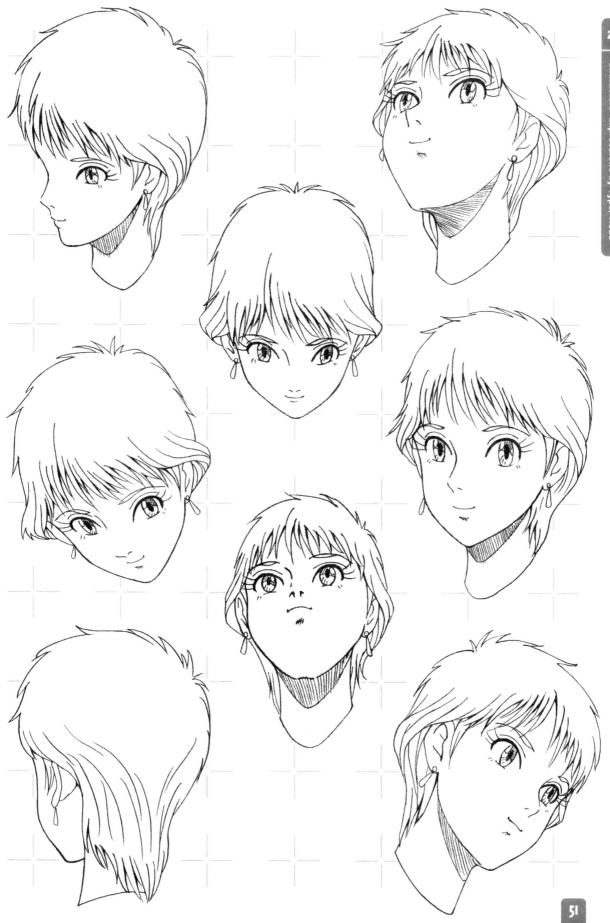

Characters' Expressions by Type/ Head — Simple Type A/Boy

The opposite of the "Fleeting Bishounen." He is cheerful, lively, brave and tough. Draw sparkling eyes and a tightly closed mouth to accentuate his boyish youthfulness. The large, round jet-black irises emphasize his positivity and trust in people. Take care to distinguish him from the character on page 54 who is also an Exaggerated type of the Anime genre. This is the simplest character in the book but getting his expression right may be quite difficult.

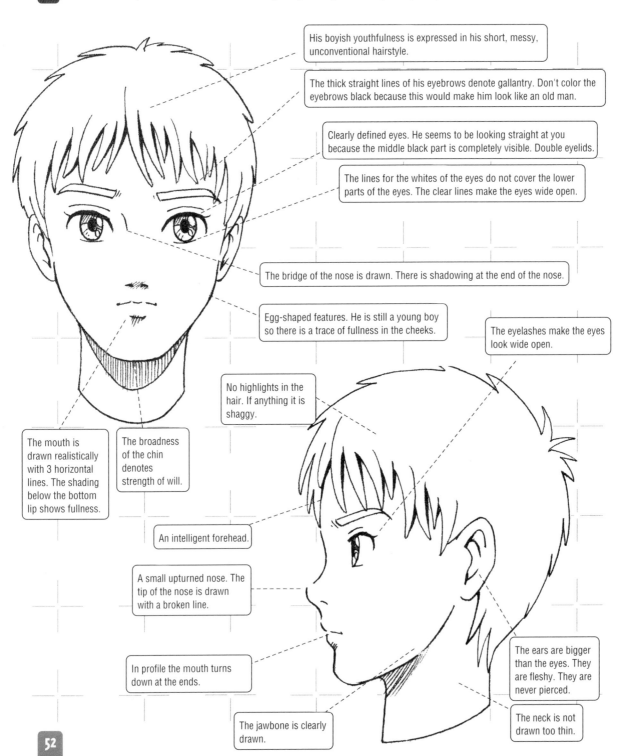

His boyish youthfulness is expressed in his short, messy, unconventional hairstyle.

The thick straight lines of his eyebrows denote gallantry. Don't color the eyebrows black because this would make him look like an old man.

Clearly defined eyes. He seems to be looking straight at you because the middle black part is completely visible. Double eyelids.

The lines for the whites of the eyes do not cover the lower parts of the eyes. The clear lines make the eyes wide open.

The bridge of the nose is drawn. There is shadowing at the end of the nose.

Egg-shaped features. He is still a young boy so there is a trace of fullness in the cheeks.

The eyelashes make the eyes look wide open.

No highlights in the hair. If anything it is shaggy.

The mouth is drawn realistically with 3 horizontal lines. The shading below the bottom lip shows fullness.

The broadness of the chin denotes strength of will.

An intelligent forehead.

A small upturned nose. The tip of the nose is drawn with a broken line.

In profile the mouth turns down at the ends.

The ears are bigger than the eyes. They are fleshy. They are never pierced.

The jawbone is clearly drawn.

The neck is not drawn too thin.

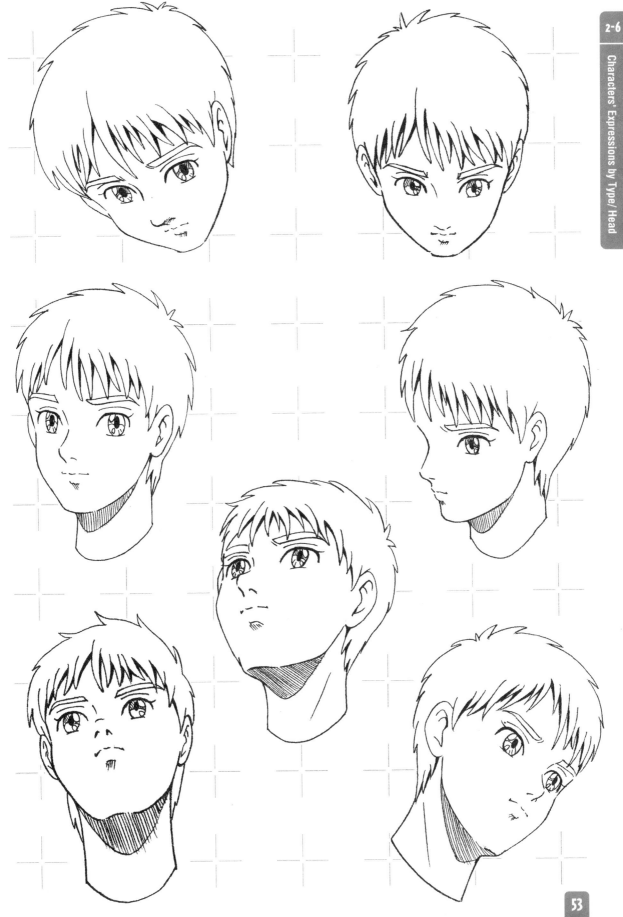

Characters' Expressions by Type/ Head **Simple Type B/Girl**

She is quiet, and doesn't say much so you don't know what she is thinking. She is slight of build and everything apart from her eyes is drawn small and thin. She is well mannered and not rebellious. She is expressionless and uncommunicative. Express her closed heart by drawing down-turned eyebrows and thin irises, and using a vague color for her eyes. Her ears and eyes are not completely visible.

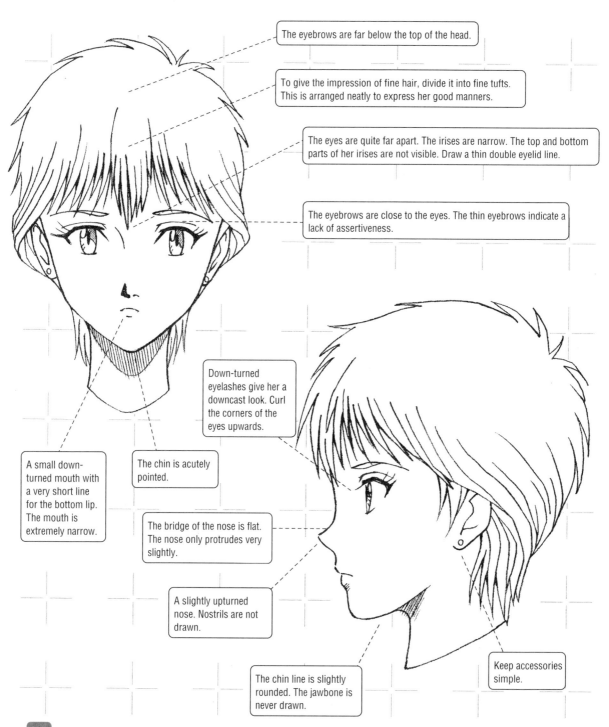

The eyebrows are far below the top of the head.

To give the impression of fine hair, divide it into fine tufts. This is arranged neatly to express her good manners.

The eyes are quite far apart. The irises are narrow. The top and bottom parts of her irises are not visible. Draw a thin double eyelid line.

The eyebrows are close to the eyes. The thin eyebrows indicate a lack of assertiveness.

Down-turned eyelashes give her a downcast look. Curl the corners of the eyes upwards.

A small down-turned mouth with a very short line for the bottom lip. The mouth is extremely narrow.

The chin is acutely pointed.

The bridge of the nose is flat. The nose only protrudes very slightly.

A slightly upturned nose. Nostrils are not drawn.

Keep accessories simple.

The chin line is slightly rounded. The jawbone is never drawn.

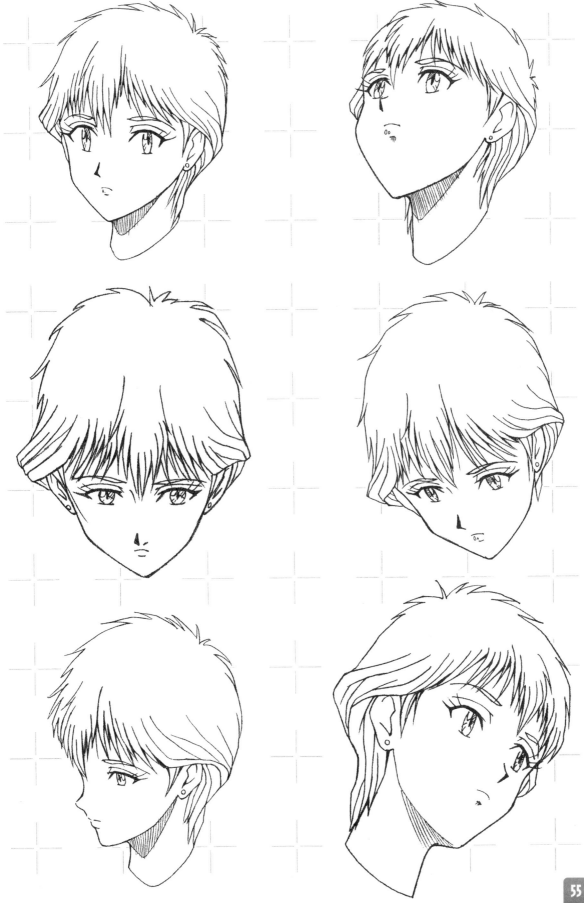

A girlish, delicate, quiet boy. Like the girl, he is introverted, uncommunicative and self-effacing. Draw him with a lonely expression on his face as if he is always worried about something. His delicate nature is evident in the sharply pointed features such as the cheeks, chin, eyes and nose. Draw his neck thin like the girl's. Out of all the characters featured in this book, it is probably most difficult to distinguish between boy and girl in Simple Type B.

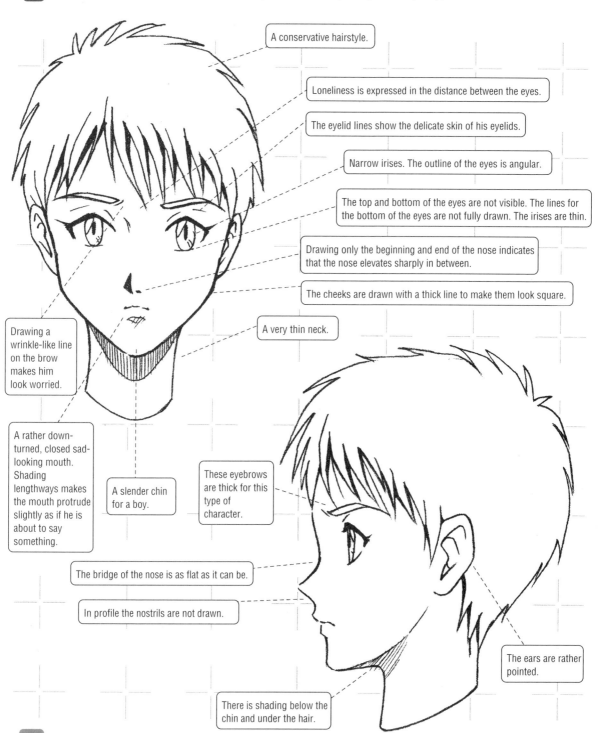

A conservative hairstyle.

Loneliness is expressed in the distance between the eyes.

The eyelid lines show the delicate skin of his eyelids.

Narrow irises. The outline of the eyes is angular.

The top and bottom of the eyes are not visible. The lines for the bottom of the eyes are not fully drawn. The irises are thin.

Drawing only the beginning and end of the nose indicates that the nose elevates sharply in between.

The cheeks are drawn with a thick line to make them look square.

A very thin neck.

Drawing a wrinkle-like line on the brow makes him look worried.

A rather down-turned, closed sad-looking mouth. Shading lengthways makes the mouth protrude slightly as if he is about to say something.

A slender chin for a boy.

These eyebrows are thick for this type of character.

The bridge of the nose is as flat as it can be.

In profile the nostrils are not drawn.

The ears are rather pointed.

There is shading below the chin and under the hair.

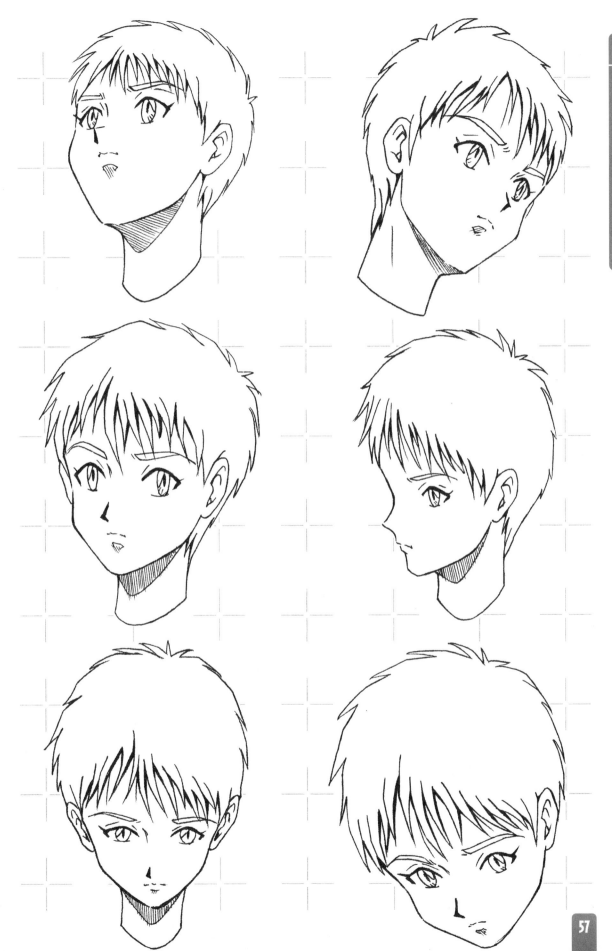

Most important is the purity of her image because she is not of this world. Whatever is said, she is an unemotional and strong-willed girl. It seems as if she is always staring far into the distance. She is gentle and speaks little. Draw her carefree as if she is floating above this world untouched by mundane things. You must draw everything in fine detail. You very rarely view her from below. But practice drawing her because she features in momentous scenes of grace and resolve. When she faces downward, her eyes close slightly.

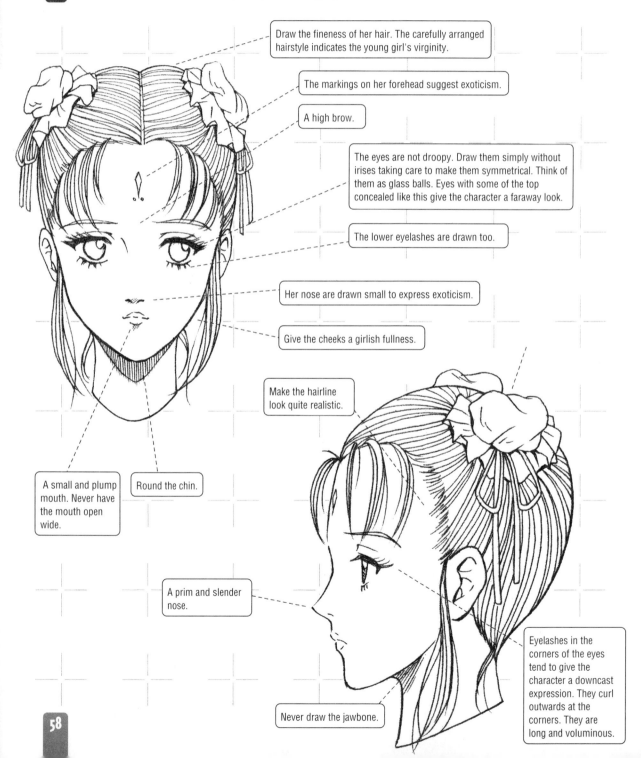

Draw the fineness of her hair. The carefully arranged hairstyle indicates the young girl's virginity.

The markings on her forehead suggest exoticism.

A high brow.

The eyes are not droopy. Draw them simply without irises taking care to make them symmetrical. Think of them as glass balls. Eyes with some of the top concealed like this give the character a faraway look.

The lower eyelashes are drawn too.

Her nose are drawn small to express exoticism.

Give the cheeks a girlish fullness.

Make the hairline look quite realistic.

A small and plump mouth. Never have the mouth open wide.

Round the chin.

A prim and slender nose.

Eyelashes in the corners of the eyes tend to give the character a downcast expression. They curl outwards at the corners. They are long and voluminous.

Never draw the jawbone.

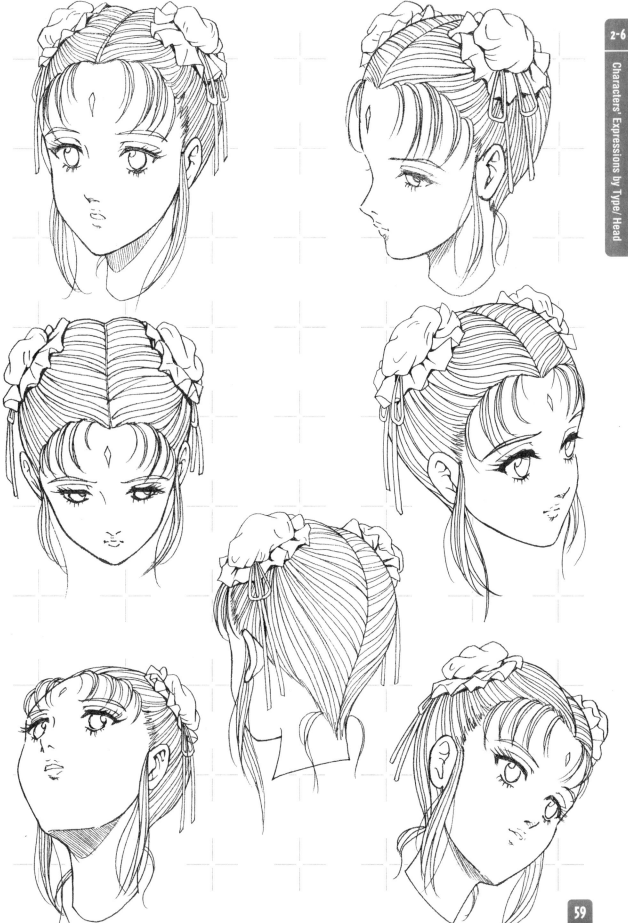

The prominent nose and fine features suggest coolness and hidden gentleness. He does not reveal his feelings and actually he is shy. He is strong-willed and passionate. Often this character is haunted by the past. Express his sense of responsibility and stoic nature in his broad chin and strong neck. He doesn't care for adornment so don't draw accessories such as earrings. Don't put highlights in his hair.

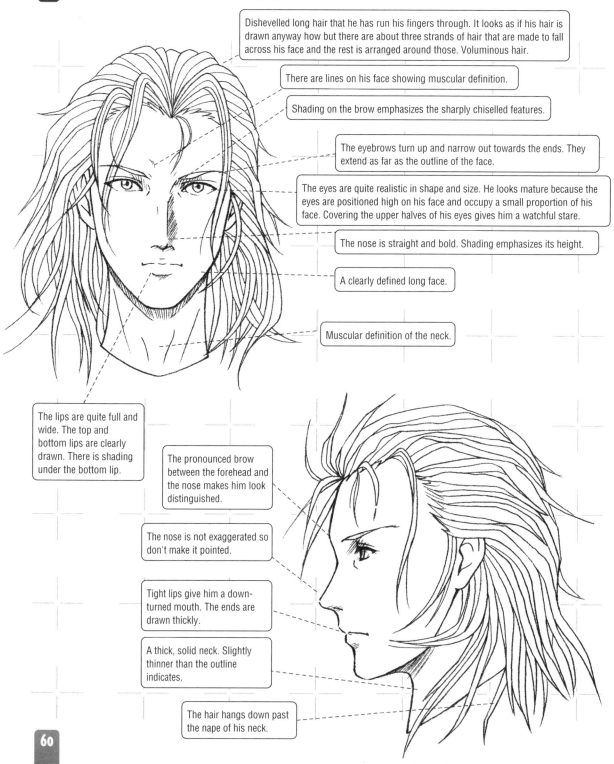

Dishevelled long hair that he has run his fingers through. It looks as if his hair is drawn anyway how but there are about three strands of hair that are made to fall across his face and the rest is arranged around those. Voluminous hair.

There are lines on his face showing muscular definition.

Shading on the brow emphasizes the sharply chiselled features.

The eyebrows turn up and narrow out towards the ends. They extend as far as the outline of the face.

The eyes are quite realistic in shape and size. He looks mature because the eyes are positioned high on his face and occupy a small proportion of his face. Covering the upper halves of his eyes gives him a watchful stare.

The nose is straight and bold. Shading emphasizes its height.

A clearly defined long face.

Muscular definition of the neck.

The lips are quite full and wide. The top and bottom lips are clearly drawn. There is shading under the bottom lip.

The pronounced brow between the forehead and the nose makes him look distinguished.

The nose is not exaggerated so don't make it pointed.

Tight lips give him a down-turned mouth. The ends are drawn thickly.

A thick, solid neck. Slightly thinner than the outline indicates.

The hair hangs down past the nape of his neck.

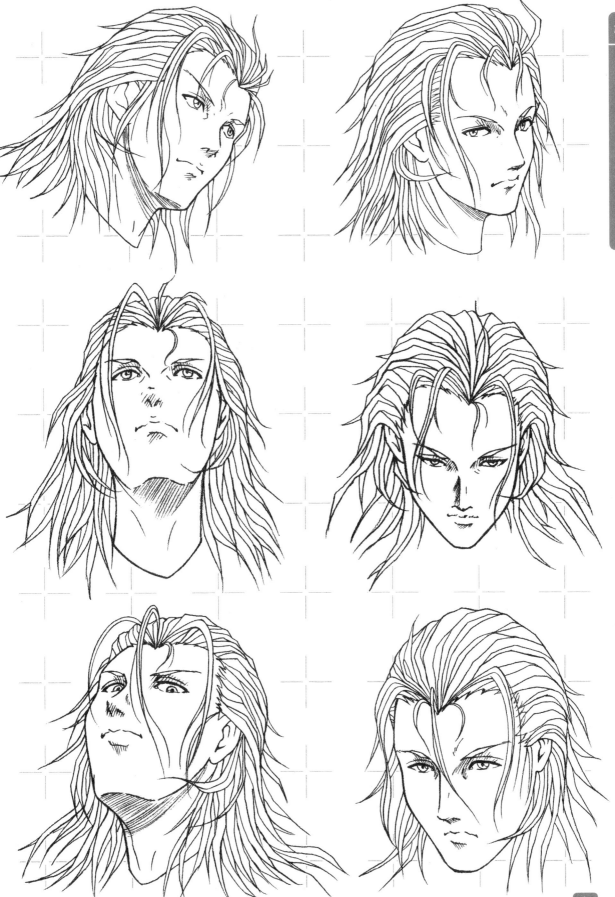

Characters' Expressions by Type/ Head **Real Type: Game Genre/Girl**

A gentle, cheerful girl who doesn't talk much. Her naivete is expressed in the large baby eyes. Draw her with flat features and few contours, a small upturned nose and tiny mouth like a Japanese festival doll. Everything is rounded. The upper parts of the eyes are slightly covered by the eyelids and this gives the face a positive expression. Take care not to conceal too much of the upper eyes or the face will become severe and cheeky (Refer to the Anti-Hero/ine). It is best to imagine her as someone you'd be happy to have around.

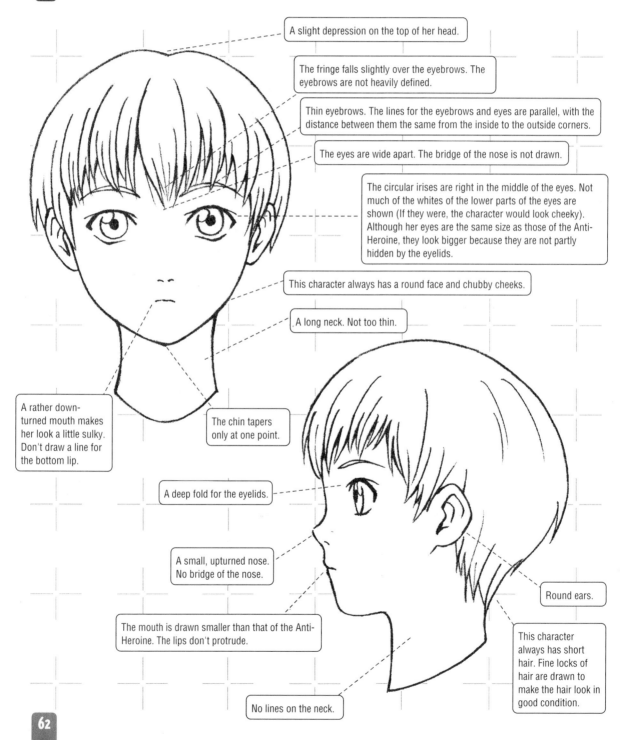

A slight depression on the top of her head.

The fringe falls slightly over the eyebrows. The eyebrows are not heavily defined.

Thin eyebrows. The lines for the eyebrows and eyes are parallel, with the distance between them the same from the inside to the outside corners.

The eyes are wide apart. The bridge of the nose is not drawn.

The circular irises are right in the middle of the eyes. Not much of the whites of the lower parts of the eyes are shown (If they were, the character would look cheeky). Although her eyes are the same size as those of the Anti-Heroine, they look bigger because they are not partly hidden by the eyelids.

This character always has a round face and chubby cheeks.

A long neck. Not too thin.

A rather down-turned mouth makes her look a little sulky. Don't draw a line for the bottom lip.

The chin tapers only at one point.

A deep fold for the eyelids.

A small, upturned nose. No bridge of the nose.

The mouth is drawn smaller than that of the Anti-Heroine. The lips don't protrude.

Round ears.

This character always has short hair. Fine locks of hair are drawn to make the hair look in good condition.

No lines on the neck.

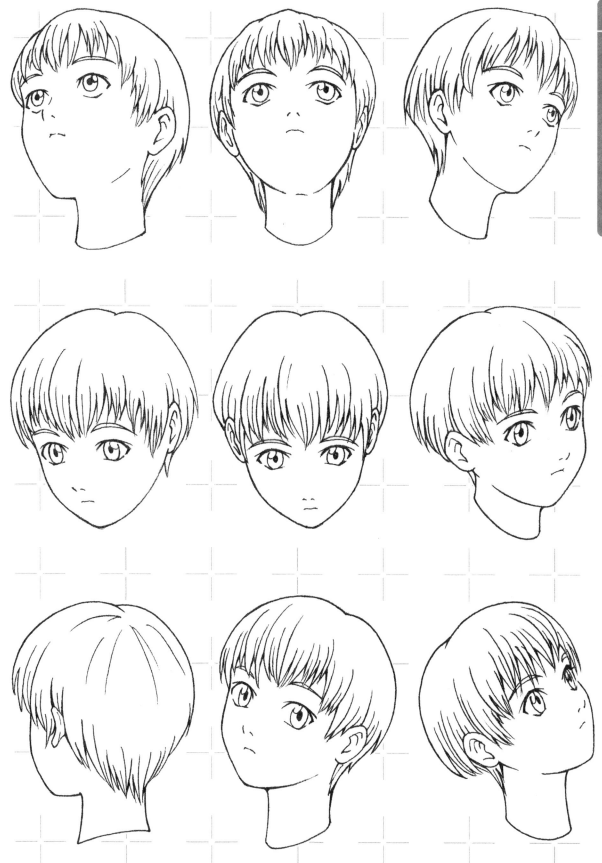

Although he is cheeky and sarcastic, he is basically a good guy. He is slender and athletic but doesn't fair well at his studies. Contrary to expectations he is easily moved to tears and has a heart of gold. He often has sisters. Generally speaking, draw him with the image of a band member in mind.

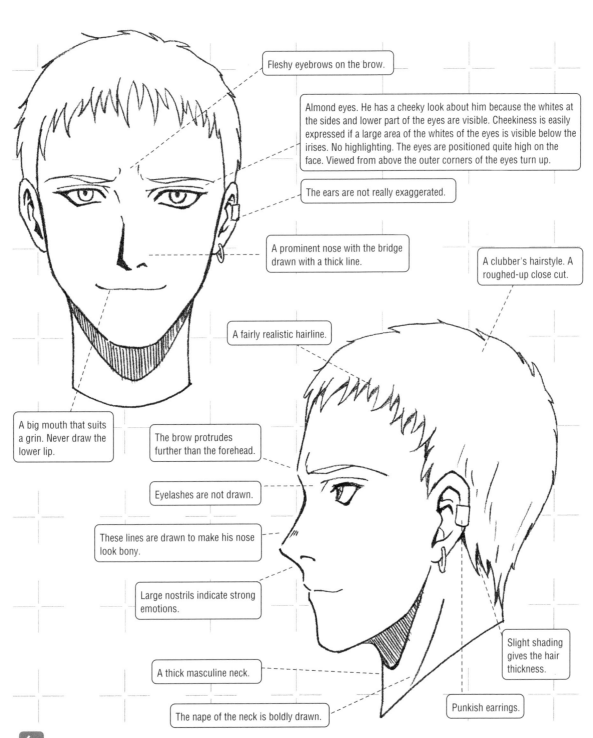

Fleshy eyebrows on the brow.

Almond eyes. He has a cheeky look about him because the whites at the sides and lower part of the eyes are visible. Cheekiness is easily expressed if a large area of the whites of the eyes is visible below the irises. No highlighting. The eyes are positioned quite high on the face. Viewed from above the outer corners of the eyes turn up.

The ears are not really exaggerated.

A prominent nose with the bridge drawn with a thick line.

A clubber's hairstyle. A roughed-up close cut.

A fairly realistic hairline.

A big mouth that suits a grin. Never draw the lower lip.

The brow protrudes further than the forehead.

Eyelashes are not drawn.

These lines are drawn to make his nose look bony.

Large nostrils indicate strong emotions.

A thick masculine neck.

Slight shading gives the hair thickness.

The nape of the neck is boldly drawn.

Punkish earrings.

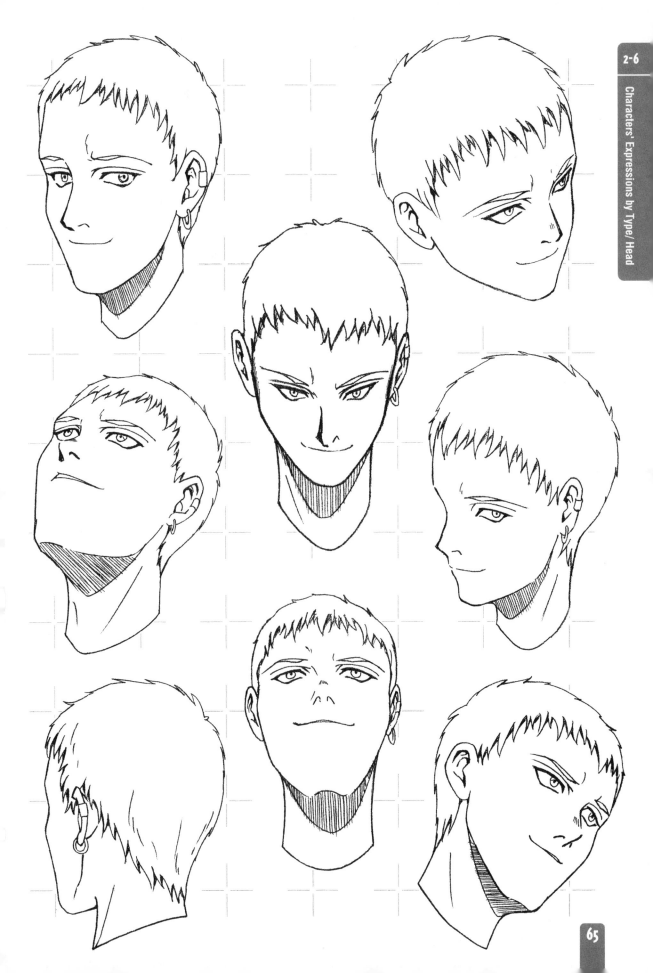

Machinery/gadgetry on her body is her trait. She has a melancholic, lonely expression. Let her speak through her eyes. Usually she has no parents and falls for older men. Even forward facing, the eyelids cover her eyes slightly. The partially concealed irises indicate her lack of openness.

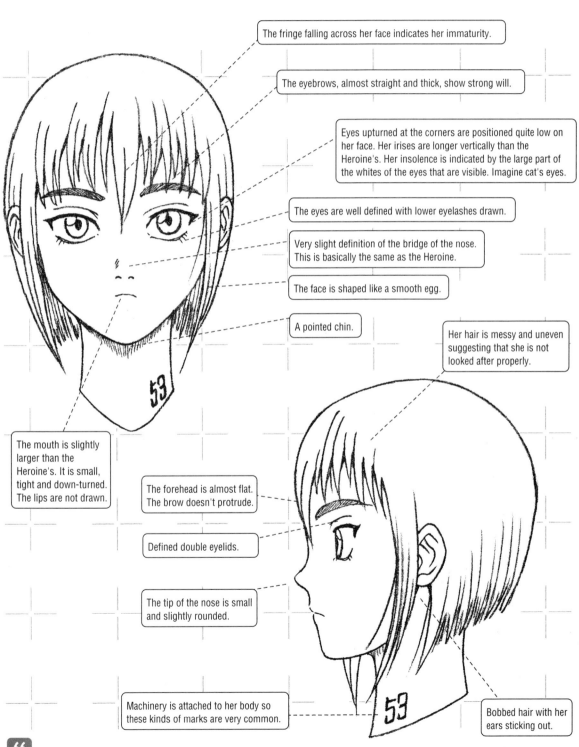

The fringe falling across her face indicates her immaturity.

The eyebrows, almost straight and thick, show strong will.

Eyes upturned at the corners are positioned quite low on her face. Her irises are longer vertically than the Heroine's. Her insolence is indicated by the large part of the whites of the eyes that are visible. Imagine cat's eyes.

The eyes are well defined with lower eyelashes drawn.

Very slight definition of the bridge of the nose. This is basically the same as the Heroine.

The face is shaped like a smooth egg.

A pointed chin.

Her hair is messy and uneven suggesting that she is not looked after properly.

The mouth is slightly larger than the Heroine's. It is small, tight and down-turned. The lips are not drawn.

The forehead is almost flat. The brow doesn't protrude.

Defined double eyelids.

The tip of the nose is small and slightly rounded.

Machinery is attached to her body so these kinds of marks are very common.

Bobbed hair with her ears sticking out.

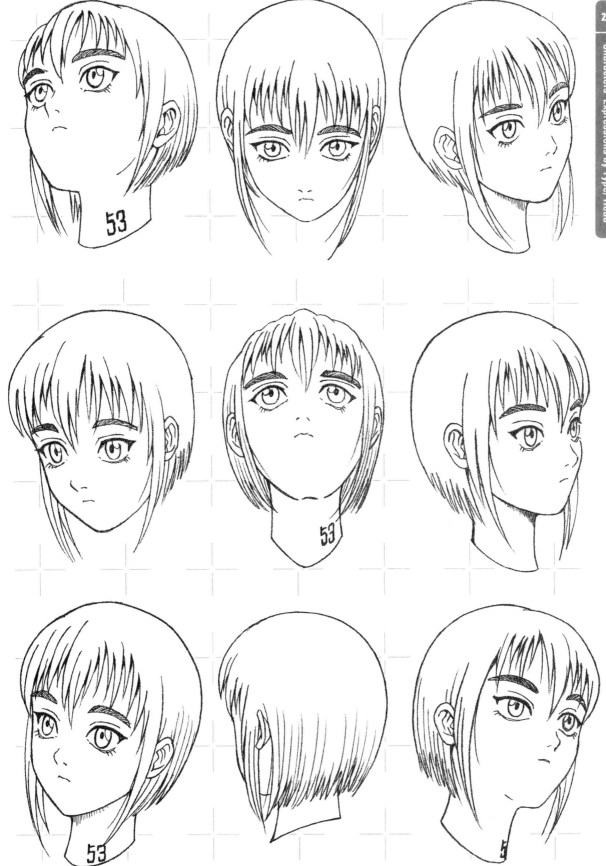

Advice from a Young Creator

小林冬至生

TOSHIO KOBAYASHI

PROFILE
Name: Toshio Kobayashi
Birthplace: Gifu Prefecture, Japan
Date of Birth: 18 December 1973

After graduating from technical college, Kobayashi started working at a Games company where he is now working on Character Design for an original animation.

The most important thing when you are drawing is **the feeling**. How are you going to express what you are thinking? That is what counts. Your drawings openly express your likes and dislikes, your personality and emotions. You are not really aware of yourself when you go about your daily life but drawing makes you take a look at yourself.

I entered this profession because ever since I was a small boy, I had aspired to become an artist. It all began twenty years ago one day when on television, I saw an old man painting on a street corner in Europe. That's when it all started and why I am drawing now.

There are no shortcuts to improving your drawing skills. The more you persevere, the better your drawings will be. Have a go at drawing everything around you, no matter what. Copy the drawings done by skilful artists. It's OK to do it just for the fun of it. Do it over and over again until the research you've done pays off and you have the material to draw what you like.Observe everything in your everyday life. Watch everything around you: people's expressions, their gestures, the way they talk, the way they move, the way they dress etc. Do the same with things. Observe the position of the light source and the shadows, colors, shapes, size, textures. Before you know it you will find yourself watching everything without even thinking. Watch, think and draw. The more, the better. Both quality and quantity are important but the most important of all is **the feeling**. If all that you draw is void of feeling, it is easy to get into the doldrums. If you do end up feeling like this, you must start from nothing again and reconsider everything, all the work you have done over the years, the pictures you like, your sketches, rough drafts and rough illustrations.

Lastly, I want to say that I lack both the technique and knowledge to draw a tenth of what I imagine. But an amateur can become a professional. And I am thinking more like a professional now than ever before.

Chapter 3
Drawing Bodies

We haven't even started yet!

Think in polygons when drawing the whole body, just as you did when you drew the heads. In the picture below the body is drawn as boxes. Though I say it again, it is the quickest way to improving your ability to **draw in three dimensions**. Once you master the basics properly you can go on to exaggerate the character design and produce good drawings.

1. **2.**

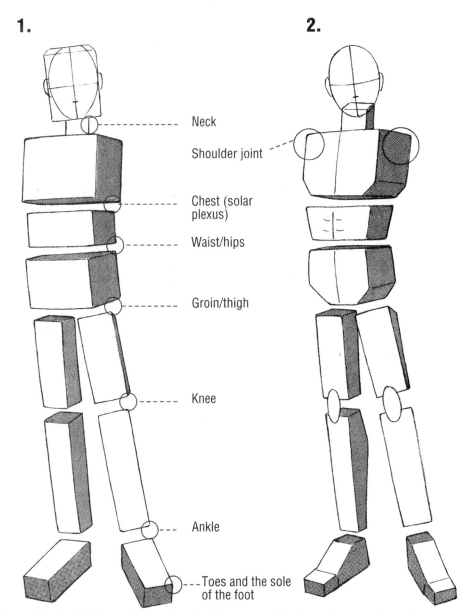

Neck

Shoulder joint

Chest (solar plexus)

Waist/hips

Groin/thigh

Knee

Ankle

Toes and the sole of the foot

1. The body is divided into moving parts (mainly at the joints). Roughly speaking, the body is separated into the head, neck, chest, waist, buttocks, thighs, calves and feet. Make sure you divide the chest into two. If the chest is struck, the solar plexus caves in. So think of it as a large joint. Always remember which direction the front part and sides of the body are facing.

2. Adding on the arms. Naturally, they come out at the sides. The knee is joined at the front. Professionals draw the knee joints as circles in their rough sketches. Take care to get the thickness of the instep and toes right. Draw the height of the instep and add the moving part for the toes.

3.

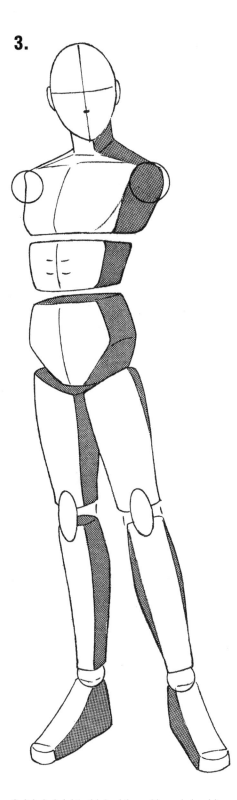

4.

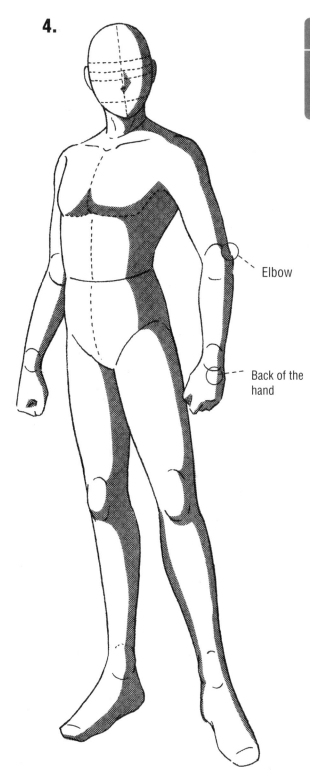

Elbow

Back of the hand

3. It is helpful to think of the ankle and shoulder joints as balls as if the human body was a robot. The soles of the feet are not flat but at an angle. The shoulders don't just come out at the sides. They are connected to the neck at an angle at the front of the body as well. Note that the calves bulge.

4. Think of the arms as moving on balls. Basically, shading depends on the direction of light. Refer to the shading on the flanks of (1). Remember that even the fingers should be shaded. Just by looking at the shading in (4), you can see how getting a feel for shading using (1) improves the drawing.

It is helpful to draw cylinders for the curved parts of the body such as the arms, hips and ankles. In the last section, we covered basic shapes. The next step is to think of smooth curved surfaces.

Take care when drawing cylinders because the curves change depending on the direction of the body. You don't have to start with curves when you are drawing something. But it enables you quickly figure out the physique of the character and draw it realistically from any angle. Look at the following explanatory drawings showing you how to draw the body from above and below.

The view from below

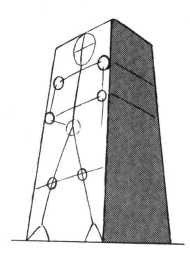

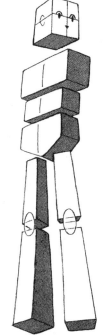

Be aware of the eye line.

The further away, the smaller the object becomes.

Start by drawing the body in squares.

The view from above.

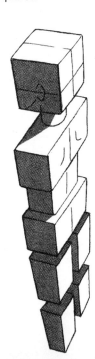

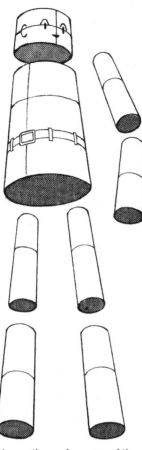

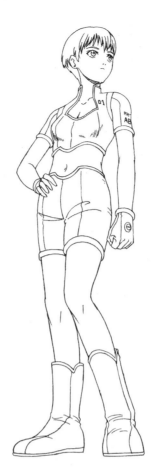

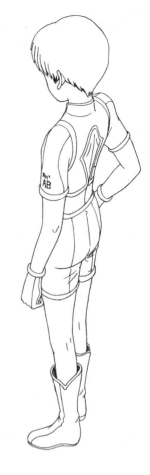

Using Cylinders for the Body Parts

The larger the surface area of the circles (the cross-sections in black), the greater the angle of the views from above and below.

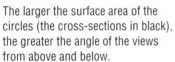

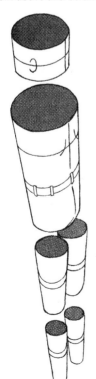

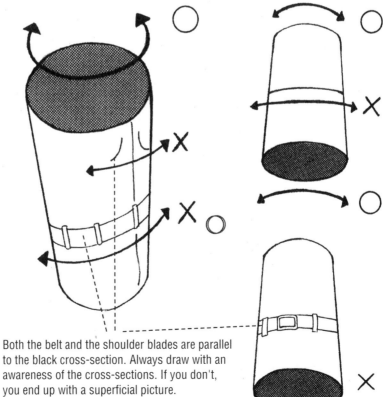

Both the belt and the shoulder blades are parallel to the black cross-section. Always draw with an awareness of the cross-sections. If you don't, you end up with a superficial picture.

 Practice drawing these cylinders even if you can't see the point of it yet.
The curved edges and the pattern are always parallel. Once you can draw a good circle without using a compass, you are ready to draw more exaggerated shapes.

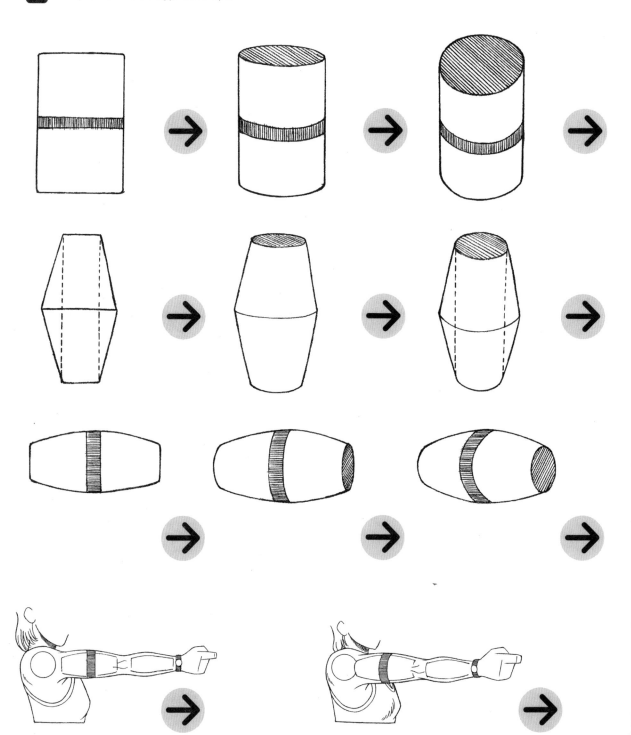

Look from left to right. The last picture is one that even the professionals don't like drawing and that's the arm front on at an angle.

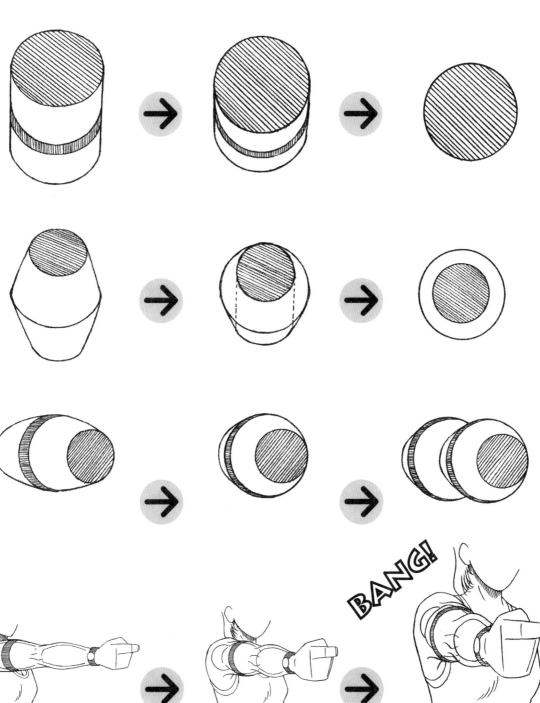

BANG!

1.

2.

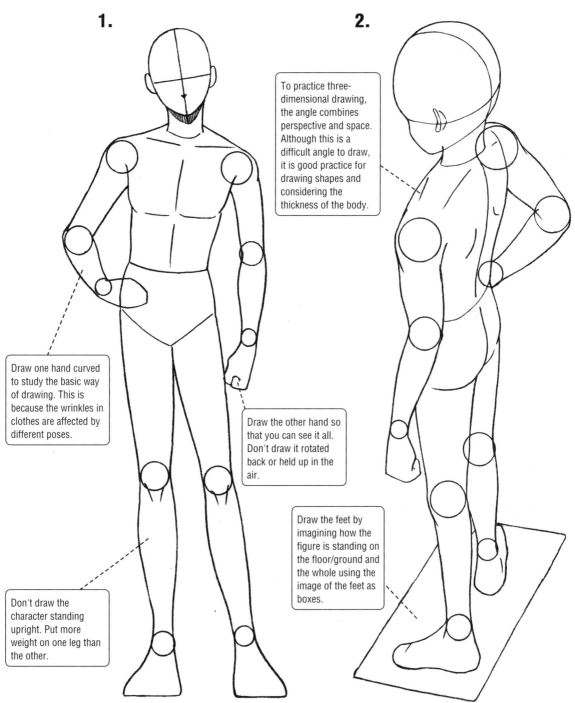

To practice three-dimensional drawing, the angle combines perspective and space. Although this is a difficult angle to draw, it is good practice for drawing shapes and considering the thickness of the body.

Draw one hand curved to study the basic way of drawing. This is because the wrinkles in clothes are affected by different poses.

Draw the other hand so that you can see it all. Don't draw it rotated back or held up in the air.

Don't draw the character standing upright. Put more weight on one leg than the other.

Draw the feet by imagining how the figure is standing on the floor/ground and the whole using the image of the feet as boxes.

1. The frontal view (Basic)
Game and Animation is not just the work of one individual. It involves the joint efforts of a group of people.Therefore **everyone must be able to understand the characters' expressions**. This front pose is a standard one that everyone can work from.

2. The view from above (Oblique view from behind)
You must be able to draw things from the down-looking angle. Often you need to set the scene and show your characters in their environment. In directional terms, the view from above is used in **scenes where the character is depressed**. Drawing the character from behind increases the sadness of the scene.

3.

4.

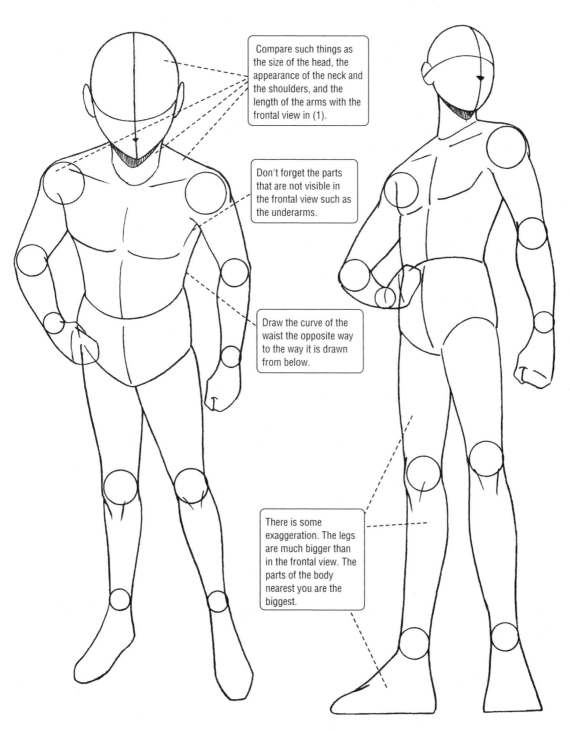

Compare such things as the size of the head, the appearance of the neck and the shoulders, and the length of the arms with the frontal view in (1).

Don't forget the parts that are not visible in the frontal view such as the underarms.

Draw the curve of the waist the opposite way to the way it is drawn from below.

There is some exaggeration. The legs are much bigger than in the frontal view. The parts of the body nearest you are the biggest.

3. The view from above (frontal)
As in (2) this pose is often used in explanatory scenes in relation to the character.

4. The view from below
This view is used to **emphasize the character's size and strength, and to express exultation and attractiveness**.

Make sure you draw girls' bodies soft and smooth, not hard looking. In the pose below, take care to get an extremely natural pose with the knees close together, the feet not wide apart and fists unclenched.

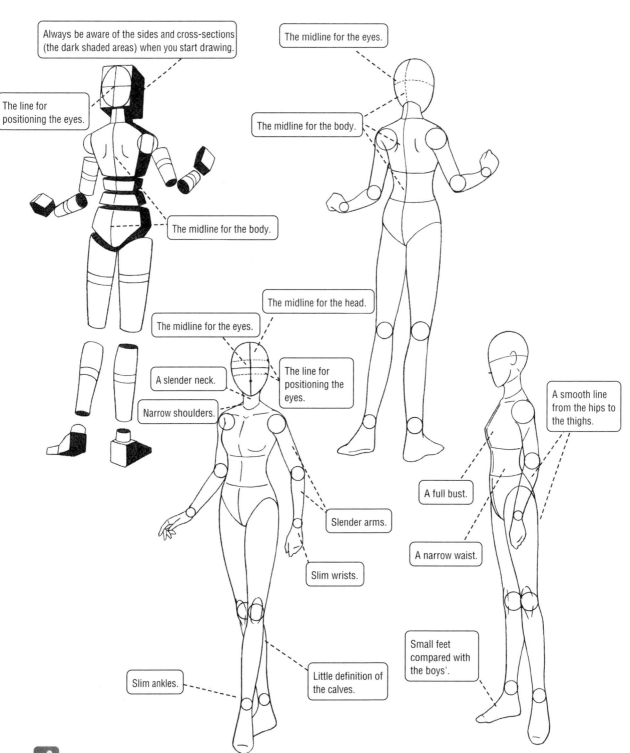

Always be aware of the sides and cross-sections (the dark shaded areas) when you start drawing.

The line for positioning the eyes.

The midline for the eyes.

The midline for the body.

The midline for the body.

The midline for the head.

The midline for the eyes.

A slender neck.

Narrow shoulders.

The line for positioning the eyes.

A full bust.

A smooth line from the hips to the thighs.

Slender arms.

A narrow waist.

Slim wrists.

Slim ankles.

Little definition of the calves.

Small feet compared with the boys'.

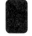

Make sure you draw the boys' bodies with muscular definition. In the pose below, the character is drawn with one hand on the hip, one fist clenched, the knees opened outwards and the feet facing outwards.

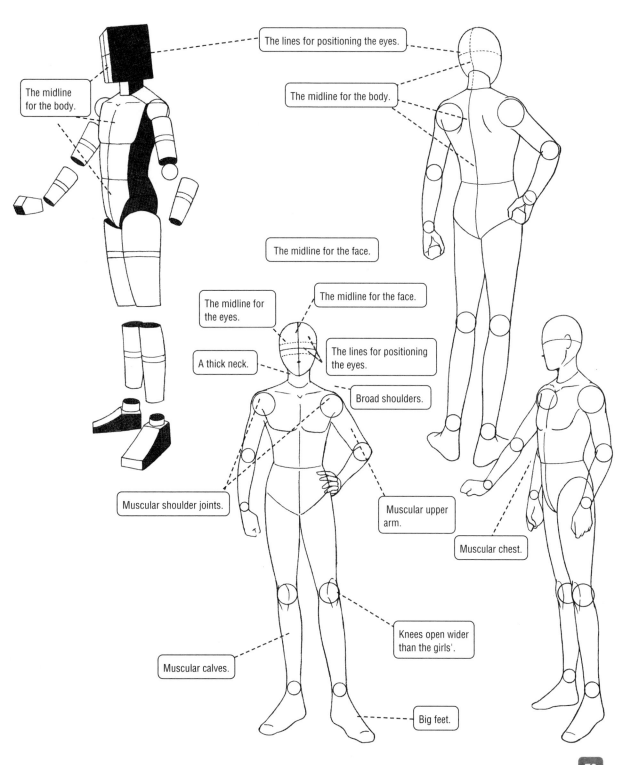

The lines for positioning the eyes.

The midline for the body.

The midline for the body.

The midline for the face.

The midline for the face.

The midline for the eyes.

A thick neck.

The lines for positioning the eyes.

Broad shoulders.

Muscular shoulder joints.

Muscular upper arm.

Muscular chest.

Knees open wider than the girls'.

Muscular calves.

Big feet.

She is a descendent of the traditional princess dressed along the lines of Takarazuka costumes. Endow her with plenty of accessories such as braids, boots and gloves. Everything is close fitting. She is extremely exaggerated, drawn with a very, very thin build and extraordinarily long limbs. She is usually in Gakuen stories, so it is vital that she wears a uniform.

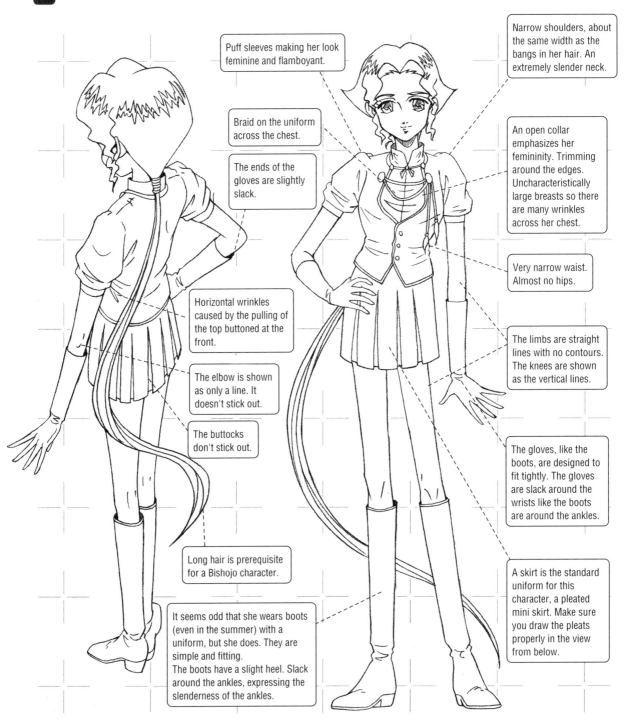

Puff sleeves making her look feminine and flamboyant.

Braid on the uniform across the chest.

The ends of the gloves are slightly slack.

Horizontal wrinkles caused by the pulling of the top buttoned at the front.

The elbow is shown as only a line. It doesn't stick out.

The buttocks don't stick out.

Long hair is prerequisite for a Bishojo character.

It seems odd that she wears boots (even in the summer) with a uniform, but she does. They are simple and fitting.
The boots have a slight heel. Slack around the ankles, expressing the slenderness of the ankles.

Narrow shoulders, about the same width as the bangs in her hair. An extremely slender neck.

An open collar emphasizes her femininity. Trimming around the edges. Uncharacteristically large breasts so there are many wrinkles across her chest.

Very narrow waist. Almost no hips.

The limbs are straight lines with no contours. The knees are shown as the vertical lines.

The gloves, like the boots, are designed to fit tightly. The gloves are slack around the wrists like the boots are around the ankles.

A skirt is the standard uniform for this character, a pleated mini skirt. Make sure you draw the pleats properly in the view from below.

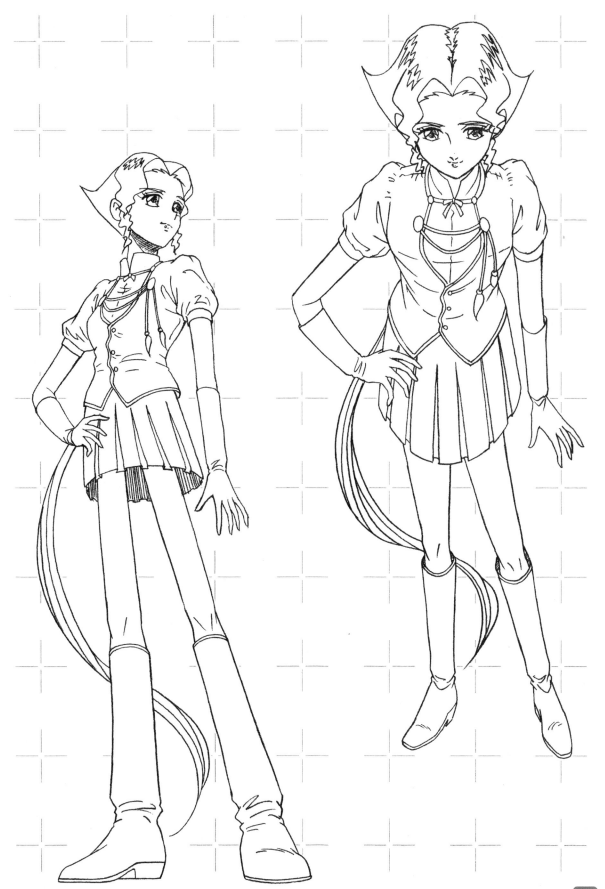

A soft uniform with a stand-up collar. The design with details such as epaulettes is reminiscent of military uniforms. Visually, it is more in the style of the Nazi uniform than the Japanese school uniform. Physically, the character has extremely long limbs like the girl, and his shoulders and hands are not masculine. He is a Bishonen, with a slight build and small chest.

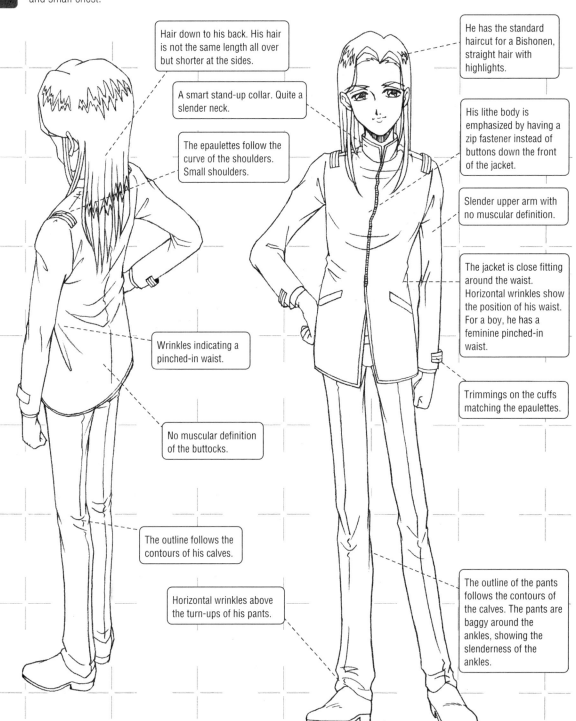

Hair down to his back. His hair is not the same length all over but shorter at the sides.

A smart stand-up collar. Quite a slender neck.

The epaulettes follow the curve of the shoulders. Small shoulders.

Wrinkles indicating a pinched-in waist.

No muscular definition of the buttocks.

The outline follows the contours of his calves.

Horizontal wrinkles above the turn-ups of his pants.

He has the standard haircut for a Bishonen, straight hair with highlights.

His lithe body is emphasized by having a zip fastener instead of buttons down the front of the jacket.

Slender upper arm with no muscular definition.

The jacket is close fitting around the waist. Horizontal wrinkles show the position of his waist. For a boy, he has a feminine pinched-in waist.

Trimmings on the cuffs matching the epaulettes.

The outline of the pants follows the contours of the calves. The pants are baggy around the ankles, showing the slenderness of the ankles.

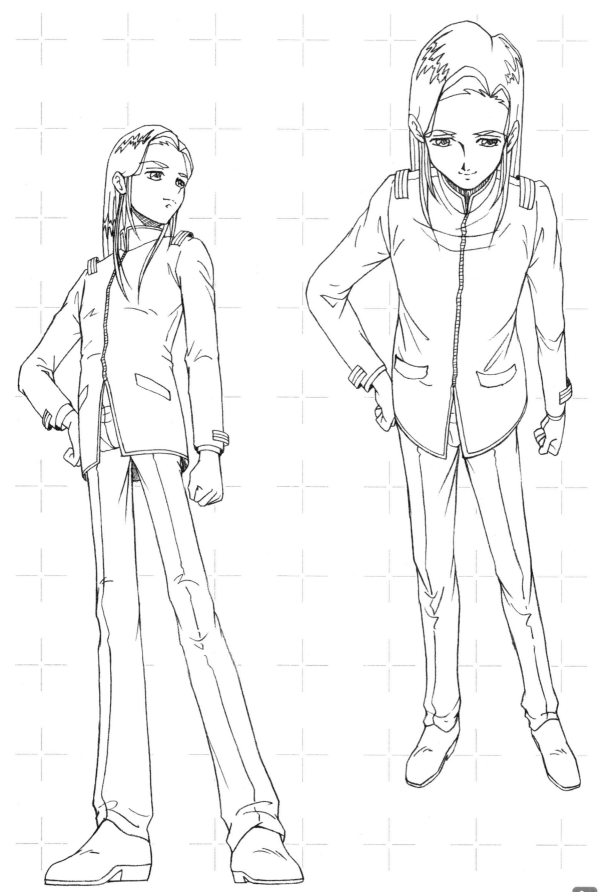

The ethnic clothes she wears are South American or African in style rather than Asian. Despite her clothes being voluminous, she has sex appeal because quite a lot of her body is exposed. Give her several flamboyant accessories. Make sure other items she is wearing are co-ordinated with this kind of ethnic patterned garment. Otherwise it will look messy. Her body is drawn with smooth lines showing her feminine contours. Her trait is ankle-length hair.

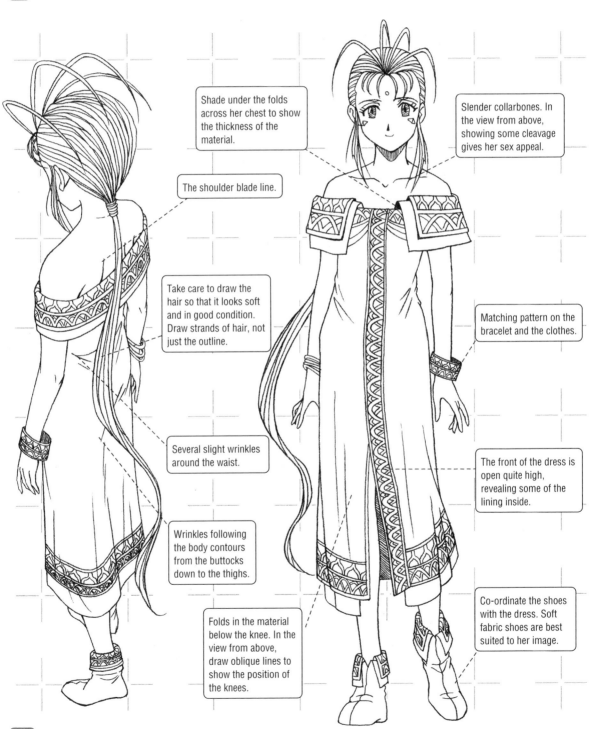

Shade under the folds across her chest to show the thickness of the material.

The shoulder blade line.

Slender collarbones. In the view from above, showing some cleavage gives her sex appeal.

Take care to draw the hair so that it looks soft and in good condition. Draw strands of hair, not just the outline.

Matching pattern on the bracelet and the clothes.

Several slight wrinkles around the waist.

The front of the dress is open quite high, revealing some of the lining inside.

Wrinkles following the body contours from the buttocks down to the thighs.

Folds in the material below the knee. In the view from above, draw oblique lines to show the position of the knees.

Co-ordinate the shoes with the dress. Soft fabric shoes are best suited to her image.

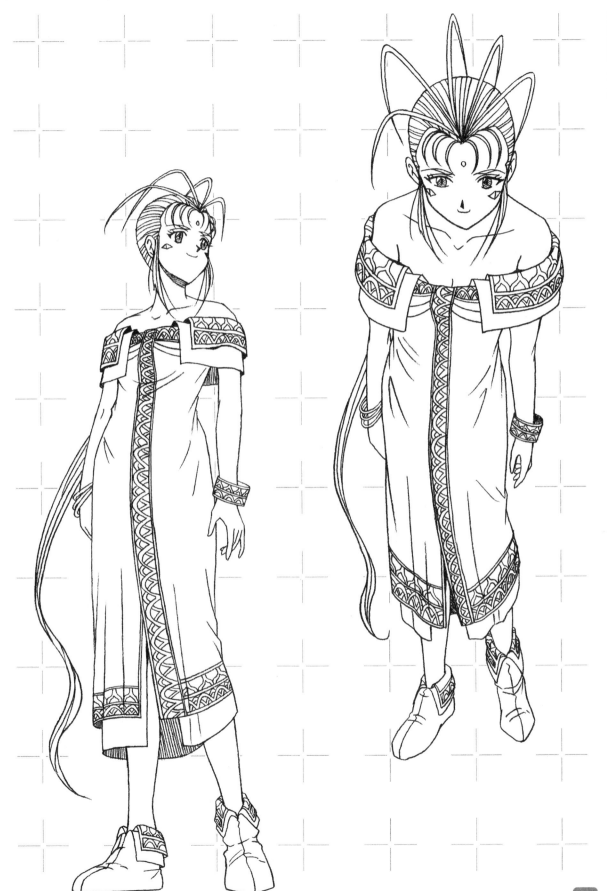

 The costume is drawn in the style of the Visual genre. Pay attention to minute detail in this character's dress because he is **stylish and flashy** (for example, the four buttons on his jacket cuffs, the flouncy fringe, two earrings in one ear, the leather shoes with a slight heel etc.). Tied back at the nape of the neck, his hair flows very long down his back.

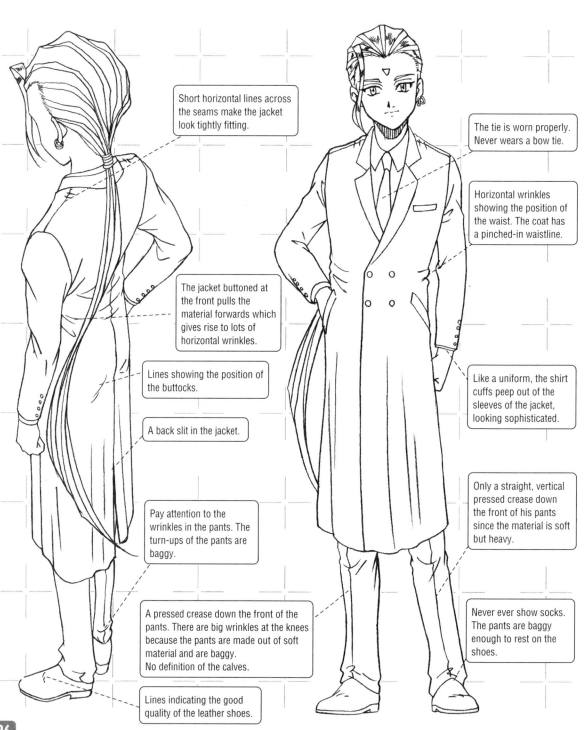

Short horizontal lines across the seams make the jacket look tightly fitting.

The tie is worn properly. Never wears a bow tie.

Horizontal wrinkles showing the position of the waist. The coat has a pinched-in waistline.

The jacket buttoned at the front pulls the material forwards which gives rise to lots of horizontal wrinkles.

Lines showing the position of the buttocks.

A back slit in the jacket.

Like a uniform, the shirt cuffs peep out of the sleeves of the jacket, looking sophisticated.

Only a straight, vertical pressed crease down the front of his pants since the material is soft but heavy.

Pay attention to the wrinkles in the pants. The turn-ups of the pants are baggy.

A pressed crease down the front of the pants. There are big wrinkles at the knees because the pants are made out of soft material and are baggy.
No definition of the calves.

Never ever show socks. The pants are baggy enough to rest on the shoes.

Lines indicating the good quality of the leather shoes.

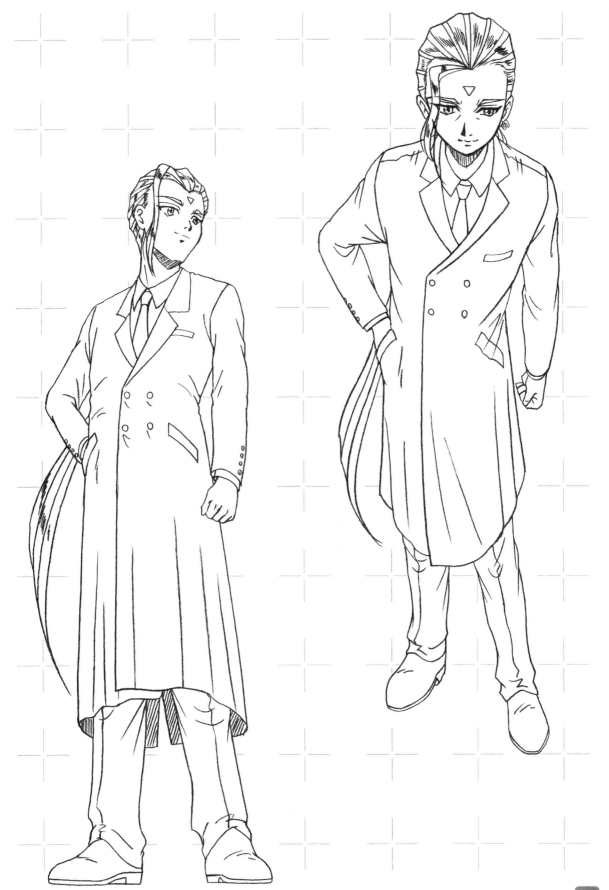

This character is **lively, healthy and sexually appealing**. She is quite loud wearing tight-fitting torn jeans and a bikini top with a transfer lip-shaped tattoo on her upper arm. Draw her with **large breasts and a pinched-in waist**. Her legs are smooth and slender from her thighs down to her calves. She also has slender ankles. Her jeans are hipsters that reveal her navel. She is slight of build so draw her elbows, neck and collarbone small. Pay attention to detail such as the ties of the bikini top.

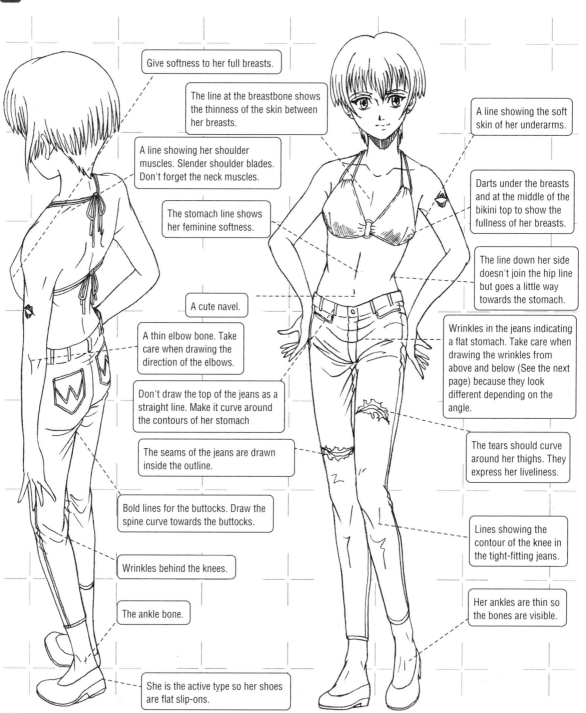

Give softness to her full breasts.

The line at the breastbone shows the thinness of the skin between her breasts.

A line showing her shoulder muscles. Slender shoulder blades. Don't forget the neck muscles.

The stomach line shows her feminine softness.

A cute navel.

A thin elbow bone. Take care when drawing the direction of the elbows.

Don't draw the top of the jeans as a straight line. Make it curve around the contours of her stomach

The seams of the jeans are drawn inside the outline.

Bold lines for the buttocks. Draw the spine curve towards the buttocks.

Wrinkles behind the knees.

The ankle bone.

She is the active type so her shoes are flat slip-ons.

A line showing the soft skin of her underarms.

Darts under the breasts and at the middle of the bikini top to show the fullness of her breasts.

The line down her side doesn't join the hip line but goes a little way towards the stomach.

Wrinkles in the jeans indicating a flat stomach. Take care when drawing the wrinkles from above and below (See the next page) because they look different depending on the angle.

The tears should curve around her thighs. They express her liveliness.

Lines showing the contour of the knee in the tight-fitting jeans.

Her ankles are thin so the bones are visible.

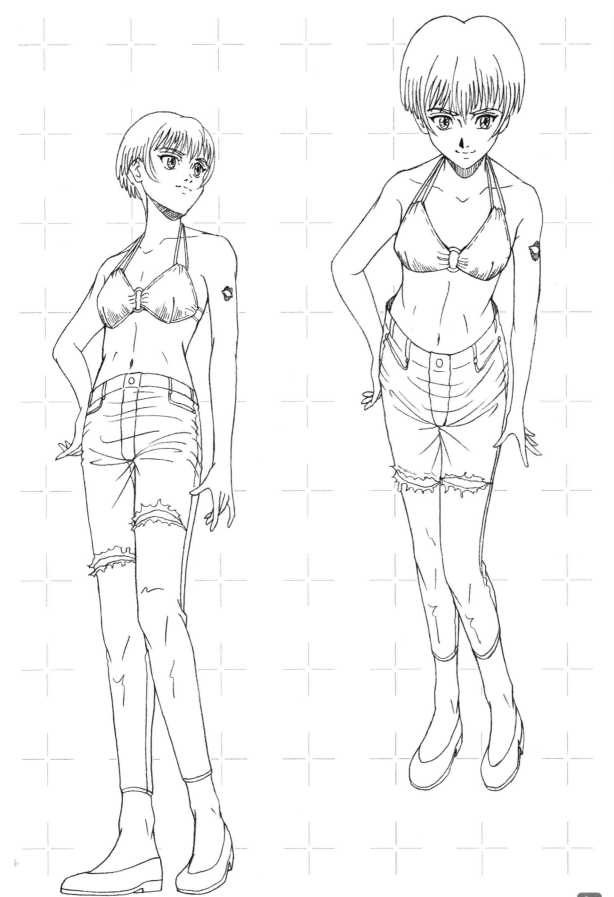

Draw this lively joker with **a rough and casual style**. He has thin legs with his thighs and calves about the same thickness. Dress him in simple, fitting clothes without complicating his dress with accessories. The short-sleeved T-shirt next to his skin is thinner than his leather jacket so put lots of wrinkles in it. Imagine him **as an agile, slender Shounen** always on the move.

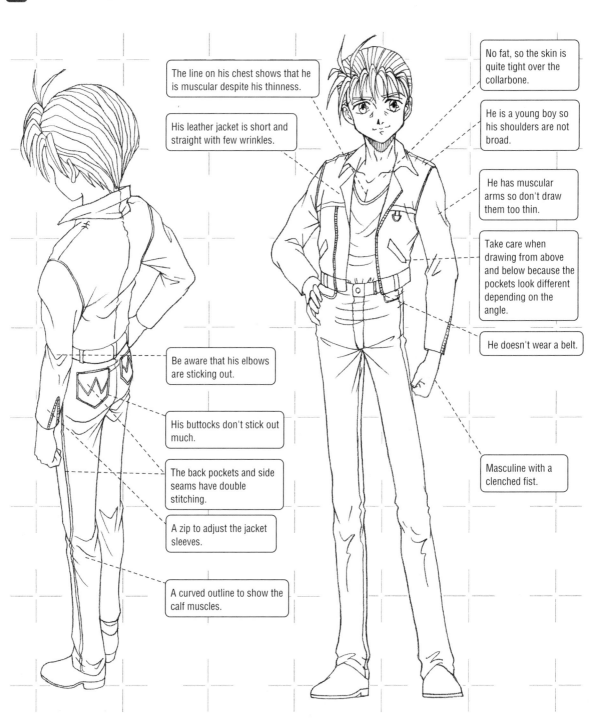

The line on his chest shows that he is muscular despite his thinness.

His leather jacket is short and straight with few wrinkles.

No fat, so the skin is quite tight over the collarbone.

He is a young boy so his shoulders are not broad.

He has muscular arms so don't draw them too thin.

Take care when drawing from above and below because the pockets look different depending on the angle.

He doesn't wear a belt.

Be aware that his elbows are sticking out.

His buttocks don't stick out much.

The back pockets and side seams have double stitching.

A zip to adjust the jacket sleeves.

Masculine with a clenched fist.

A curved outline to show the calf muscles.

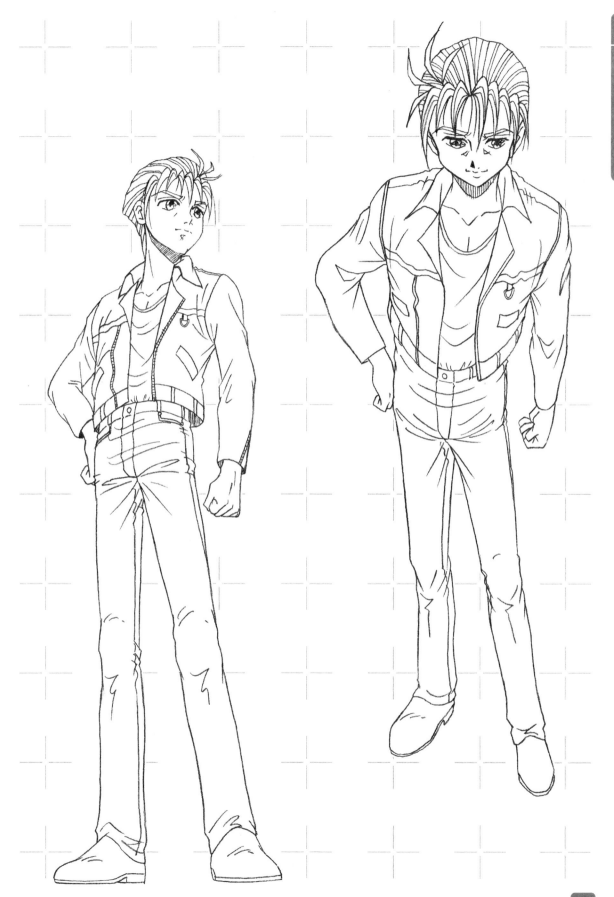

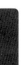

When you are drawing this ethnic dress, you must consider the total design of the shoes, earrings and clothes if you want it to work. You must have her co-ordinated to show that she comes from a very different world from that of the Heroine. If anything, draw this type of character as gender neutral without emphasizing her femininity. Her dress must be designed to enable lively movement.

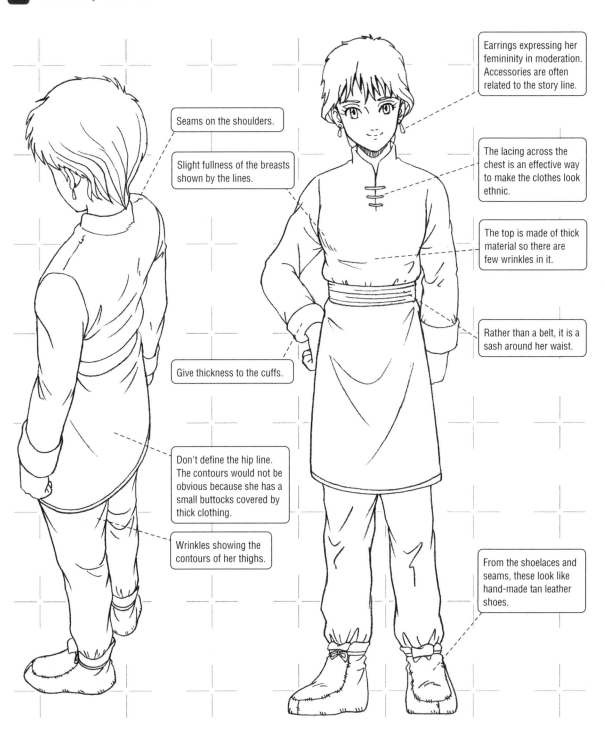

Seams on the shoulders.

Slight fullness of the breasts shown by the lines.

Earrings expressing her femininity in moderation. Accessories are often related to the story line.

The lacing across the chest is an effective way to make the clothes look ethnic.

The top is made of thick material so there are few wrinkles in it.

Rather than a belt, it is a sash around her waist.

Give thickness to the cuffs.

Don't define the hip line. The contours would not be obvious because she has a small buttocks covered by thick clothing.

Wrinkles showing the contours of her thighs.

From the shoelaces and seams, these look like hand-made tan leather shoes.

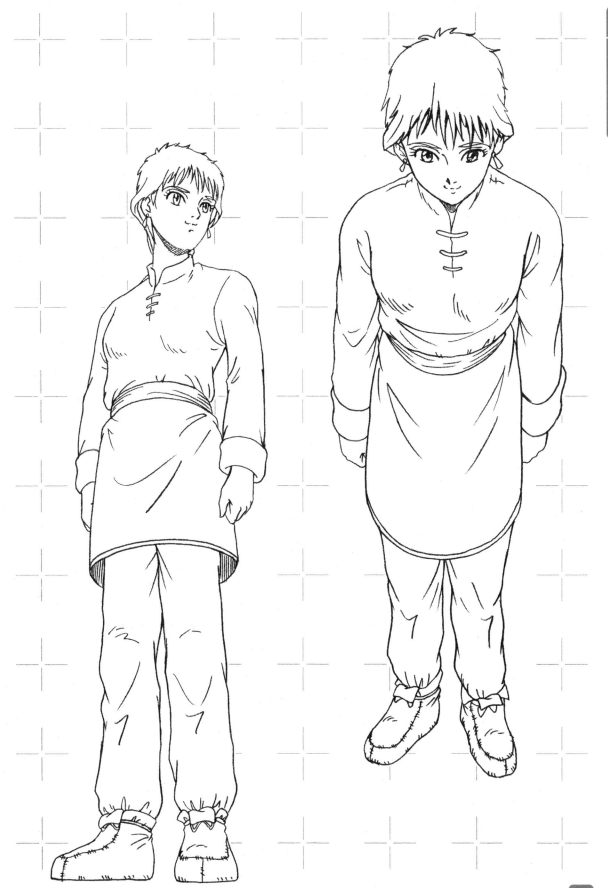

You have to try and make costume look real when the character **wears such a complex original design** that you can't buy on the streets. This character is quite muscular so when he wears something made out of thin material there will be wrinkles showing his muscular definition. He has a lively personality and must be able to move freely in the clothes. So simulate how his clothes would feel by asking questions such as "Will he be able to move if I tie it here?" and trying it out yourself. With the sash and laces, make sure you draw the whole thing properly from the knot to the ends. If you make the ends so short that he wouldn't be able to do them up, you lose the realism of the character.

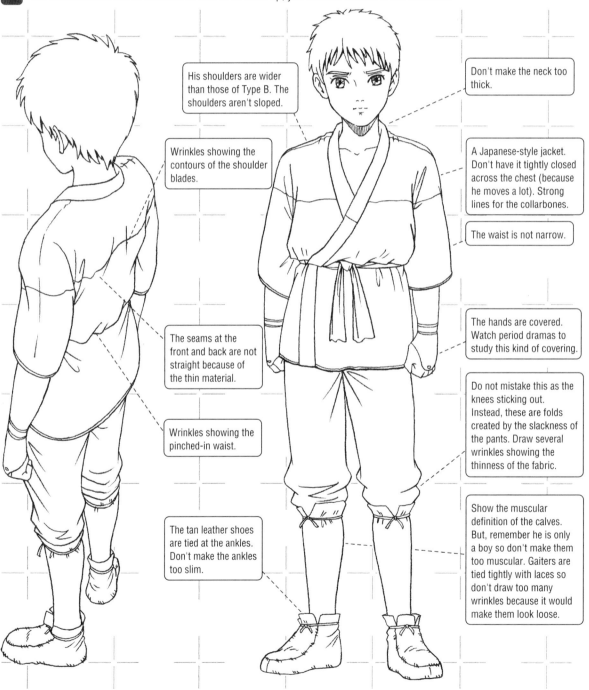

His shoulders are wider than those of Type B. The shoulders aren't sloped.

Wrinkles showing the contours of the shoulder blades.

The seams at the front and back are not straight because of the thin material.

Wrinkles showing the pinched-in waist.

The tan leather shoes are tied at the ankles. Don't make the ankles too slim.

Don't make the neck too thick.

A Japanese-style jacket. Don't have it tightly closed across the chest (because he moves a lot). Strong lines for the collarbones.

The waist is not narrow.

The hands are covered. Watch period dramas to study this kind of covering.

Do not mistake this as the knees sticking out. Instead, these are folds created by the slackness of the pants. Draw several wrinkles showing the thinness of the fabric.

Show the muscular definition of the calves. But, remember he is only a boy so don't make them too muscular. Gaiters are tied tightly with laces so don't draw too many wrinkles because it would make them look loose.

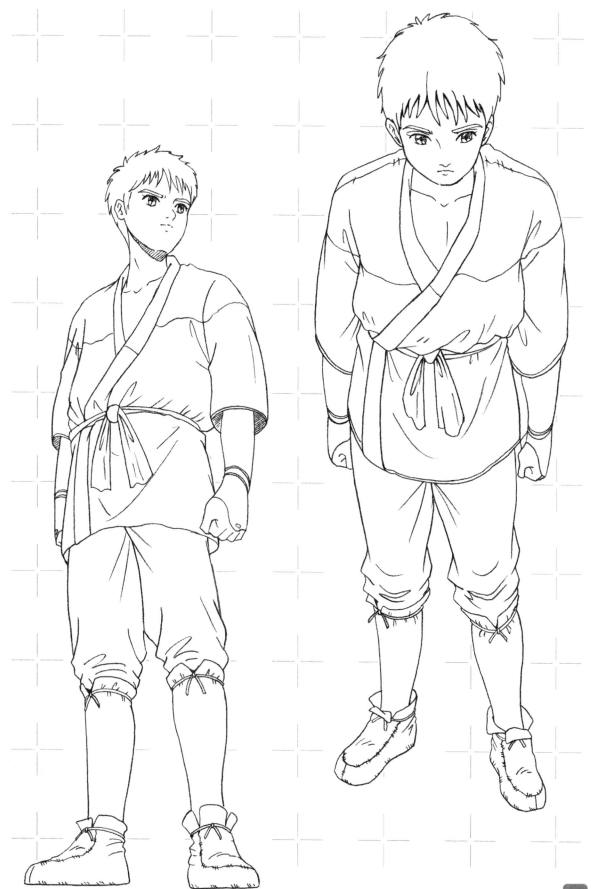

Simple Type B/Girl

She is often used in **Gakuen** stories so you usually see her in a uniform. It is best to practice drawing the several varieties of uniforms. **The blazer** is more fashionable than the sailor suit at the moment. It is safer to avoid certain fads such as loose socks because they will go out of fashion too quickly. She is a Shojo, thin and slight of frame.

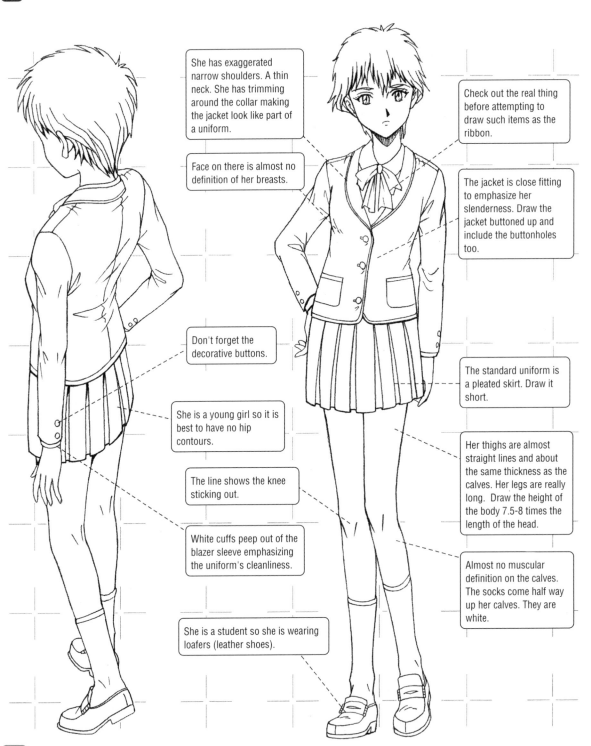

She has exaggerated narrow shoulders. A thin neck. She has trimming around the collar making the jacket look like part of a uniform.

Face on there is almost no definition of her breasts.

Check out the real thing before attempting to draw such items as the ribbon.

The jacket is close fitting to emphasize her slenderness. Draw the jacket buttoned up and include the buttonholes too.

Don't forget the decorative buttons.

She is a young girl so it is best to have no hip contours.

The line shows the knee sticking out.

White cuffs peep out of the blazer sleeve emphasizing the uniform's cleanliness.

She is a student so she is wearing loafers (leather shoes).

The standard uniform is a pleated skirt. Draw it short.

Her thighs are almost straight lines and about the same thickness as the calves. Her legs are really long. Draw the height of the body 7.5-8 times the length of the head.

Almost no muscular definition on the calves. The socks come half way up her calves. They are white.

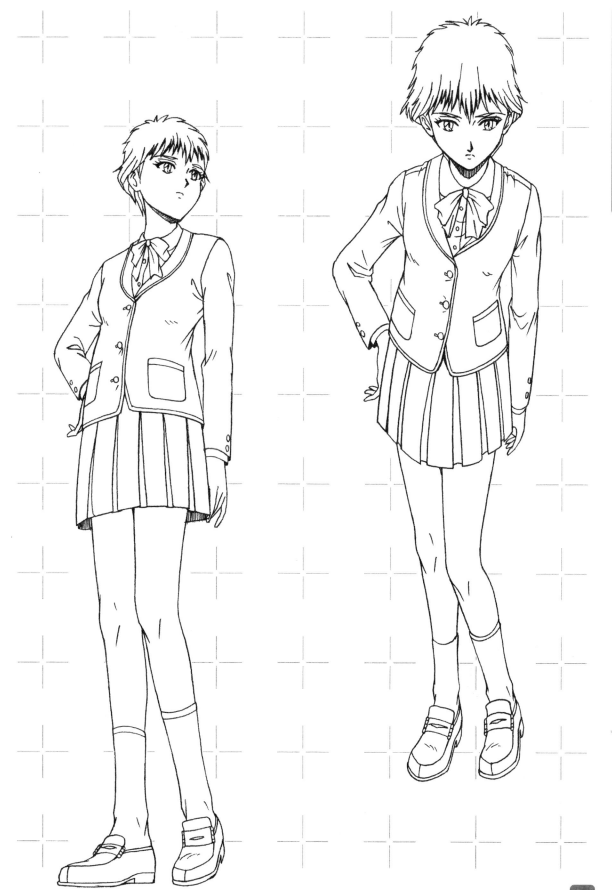

Exaggerate his physique making his shoulders narrow relative to the size of his head so that he looks as if he has **a feeble constitution**. His pants are almost straight, showing almost no muscular definition. Although he is usually of junior high school age or older, it is better to imagine him as having the **slender build** of an elementary schoolboy. Take care when drawing such details as his belt, the belt loops, pockets and buttons.

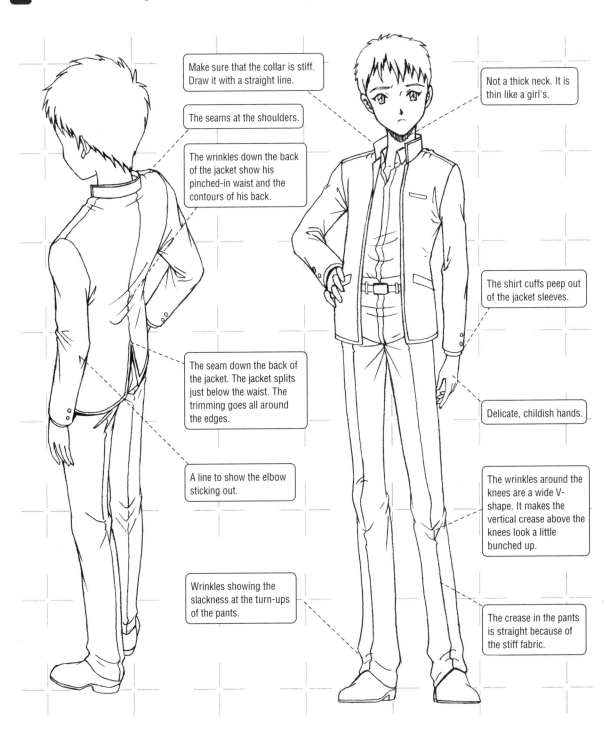

Make sure that the collar is stiff. Draw it with a straight line.

The seams at the shoulders.

The wrinkles down the back of the jacket show his pinched-in waist and the contours of his back.

Not a thick neck. It is thin like a girl's.

The shirt cuffs peep out of the jacket sleeves.

Delicate, childish hands.

The seam down the back of the jacket. The jacket splits just below the waist. The trimming goes all around the edges.

A line to show the elbow sticking out.

The wrinkles around the knees are a wide V-shape. It makes the vertical crease above the knees look a little bunched up.

Wrinkles showing the slackness at the turn-ups of the pants.

The crease in the pants is straight because of the stiff fabric.

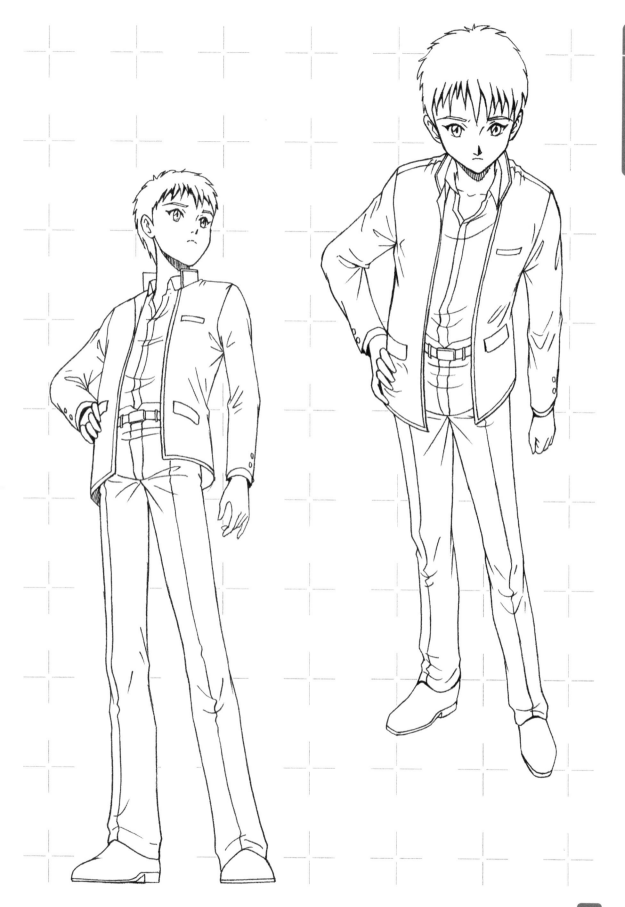

For a front on pose, don't draw her standing straight upright but tilt her hips coquettishly to put her center of gravity onto one leg. Design the fitting dress by using details from a variety of **Asian ethnic costumes**. The Chinese cheongsam and Vietnamese ao dai are commonly used, but there are also such lovely costumes as the Indian sari and the Korean national costume to chose from too. It is important to always take an interest and observe different ethnic Asian styles of dress. She has **sex appeal** wearing the simple body-hugging dress that makes her look **exotic**. Take care not to draw her breasts too large because this would make her look cheap.

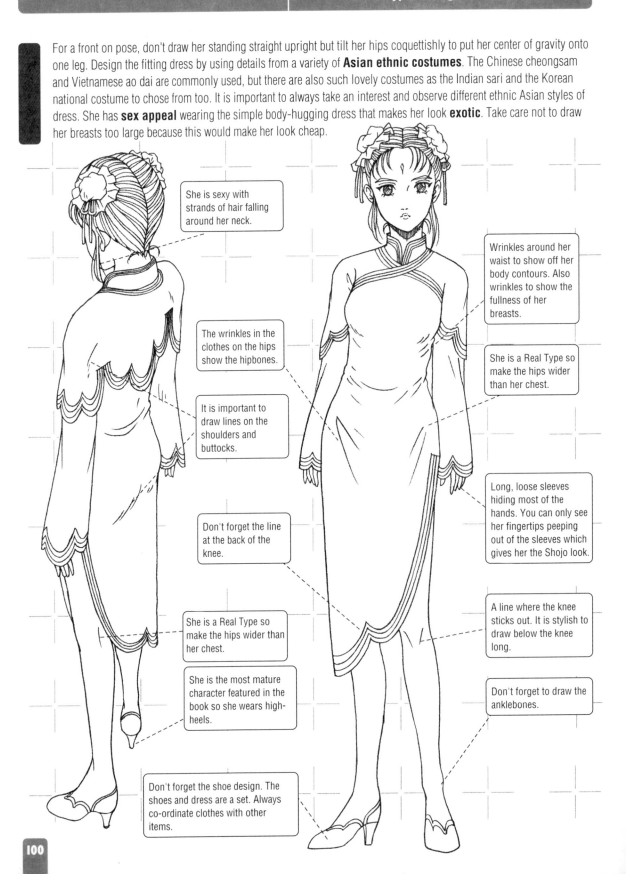

She is sexy with strands of hair falling around her neck.

Wrinkles around her waist to show off her body contours. Also wrinkles to show the fullness of her breasts.

The wrinkles in the clothes on the hips show the hipbones.

She is a Real Type so make the hips wider than her chest.

It is important to draw lines on the shoulders and buttocks.

Long, loose sleeves hiding most of the hands. You can only see her fingertips peeping out of the sleeves which gives her the Shojo look.

Don't forget the line at the back of the knee.

A line where the knee sticks out. It is stylish to draw below the knee long.

She is a Real Type so make the hips wider than her chest.

She is the most mature character featured in the book so she wears high-heels.

Don't forget to draw the anklebones.

Don't forget the shoe design. The shoes and dress are a set. Always co-ordinate clothes with other items.

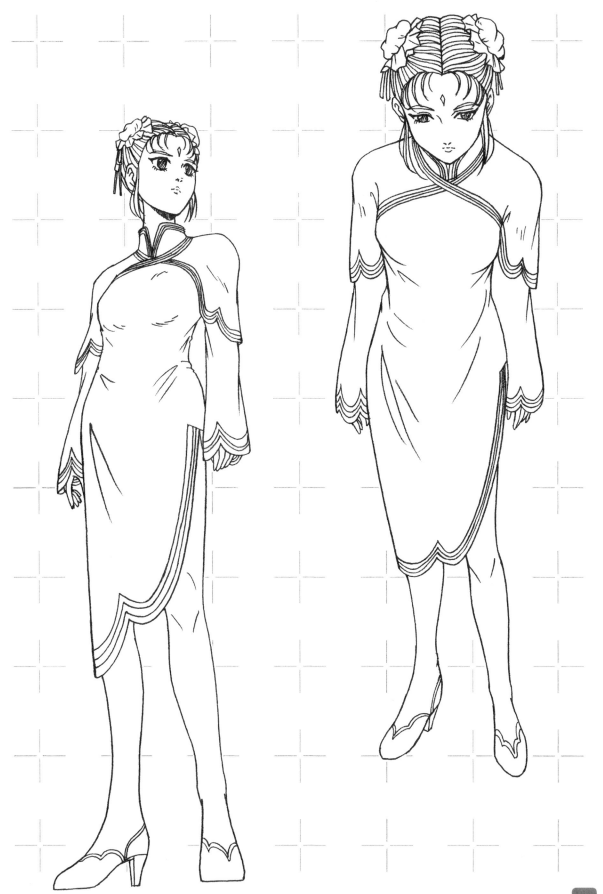

He is more **realistic** than the Real Type girl. Draw the wrinkles in his clothes with an awareness of his **masculine muscles** (their shape and definition). Pay attention to the horizontal seams of the jeans. The wrinkles are short horizontal lines, and the seams over them are drawn in three-dimension. Attention to this kind of detail makes the drawing all that more realistic.

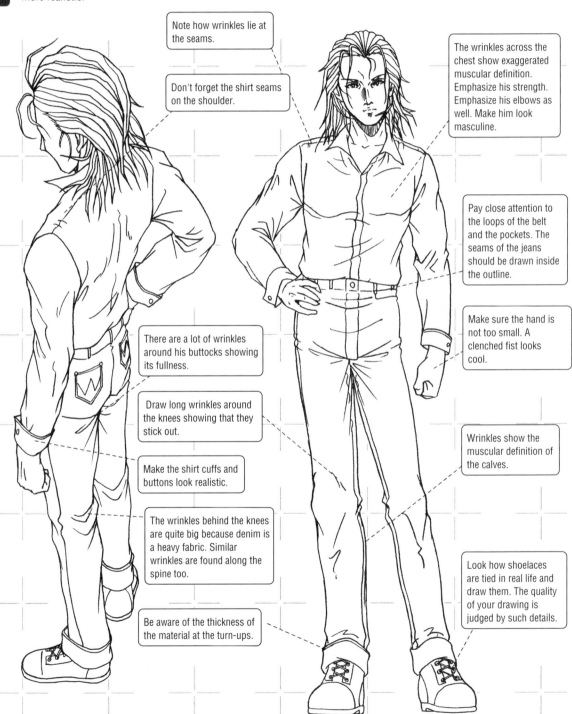

Note how wrinkles lie at the seams.

Don't forget the shirt seams on the shoulder.

The wrinkles across the chest show exaggerated muscular definition. Emphasize his strength. Emphasize his elbows as well. Make him look masculine.

Pay close attention to the loops of the belt and the pockets. The seams of the jeans should be drawn inside the outline.

Make sure the hand is not too small. A clenched fist looks cool.

There are a lot of wrinkles around his buttocks showing its fullness.

Draw long wrinkles around the knees showing that they stick out.

Make the shirt cuffs and buttons look realistic.

The wrinkles behind the knees are quite big because denim is a heavy fabric. Similar wrinkles are found along the spine too.

Be aware of the thickness of the material at the turn-ups.

Wrinkles show the muscular definition of the calves.

Look how shoelaces are tied in real life and draw them. The quality of your drawing is judged by such details.

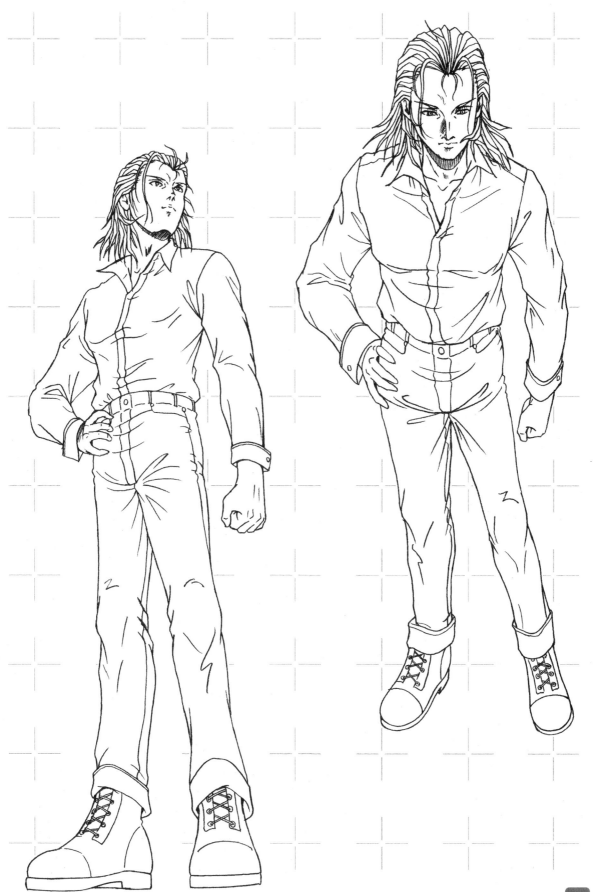

This character has **the fullest figure** out of all the characters featured in the book. Draw her with **plump** thighs, buttocks and chest etc. She has full breasts and big hips. She features in **Robot stories** so she wears a **futuristic uniform**. Make sure that you co-ordinate her clothes, gloves and boots. She is active and mixes with the boys so show her **liveliness** by not dressing her up in a skirt. To emphasize her voluptuousness, **expose a lot her body** and have her wearing shorts. The big roles usually go to the boys in SF stories so make sure that this girl stands out.

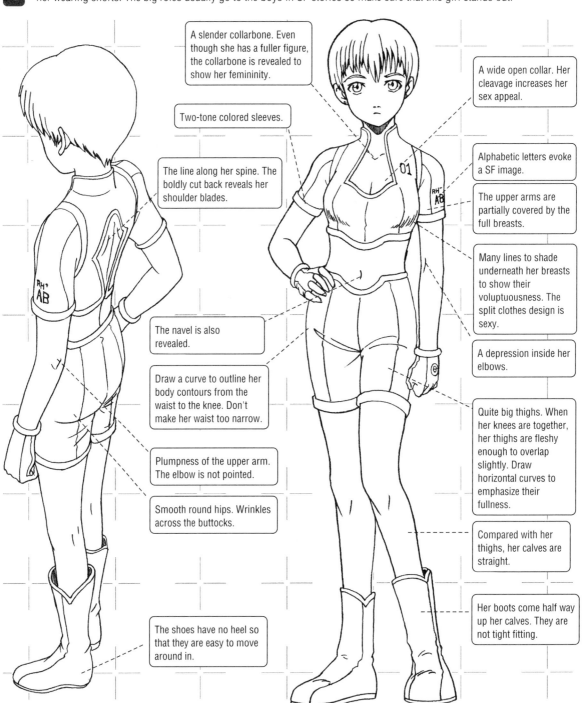

A slender collarbone. Even though she has a fuller figure, the collarbone is revealed to show her femininity.

Two-tone colored sleeves.

The line along her spine. The boldly cut back reveals her shoulder blades.

The navel is also revealed.

Draw a curve to outline her body contours from the waist to the knee. Don't make her waist too narrow.

Plumpness of the upper arm. The elbow is not pointed.

Smooth round hips. Wrinkles across the buttocks.

The shoes have no heel so that they are easy to move around in.

A wide open collar. Her cleavage increases her sex appeal.

Alphabetic letters evoke a SF image.

The upper arms are partially covered by the full breasts.

Many lines to shade underneath her breasts to show their voluptuousness. The split clothes design is sexy.

A depression inside her elbows.

Quite big thighs. When her knees are together, her thighs are fleshy enough to overlap slightly. Draw horizontal curves to emphasize their fullness.

Compared with her thighs, her calves are straight.

Her boots come half way up her calves. They are not tight fitting.

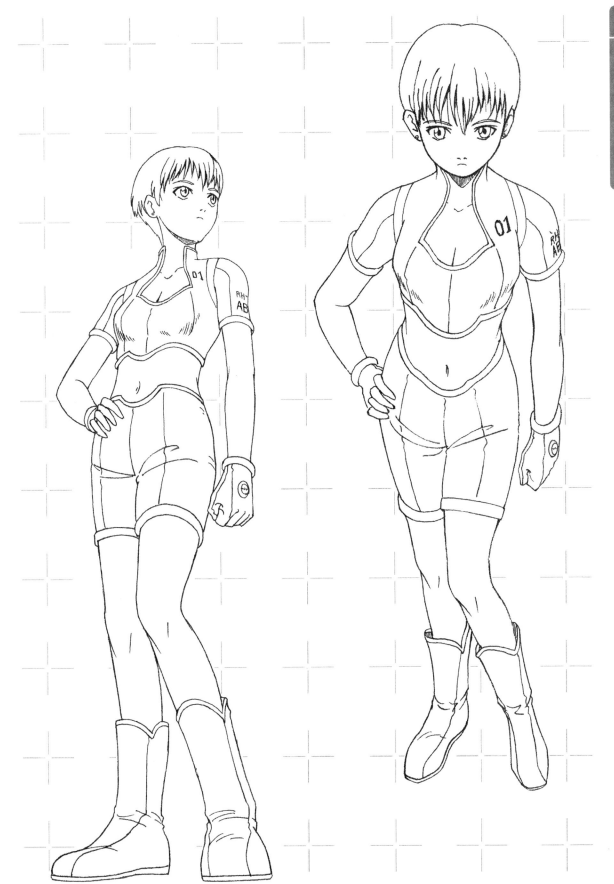

Real Type: Game Genre/Boy

His physique suggests that he is an adolescent and not a boy anymore. Draw him **as a cross between a tough guy on the streets and a macho American GI**. He is bony so he is drawn with many angular lines. His style is like his personality: wild and tenacious.

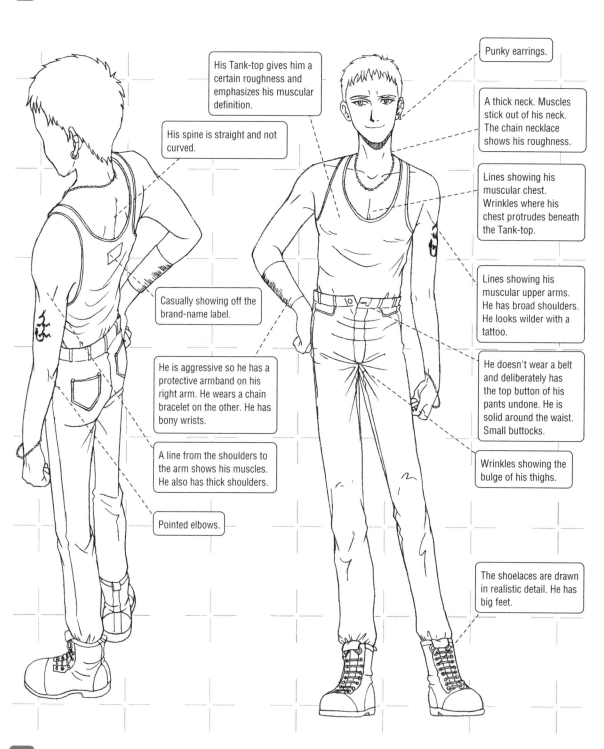

His Tank-top gives him a certain roughness and emphasizes his muscular definition.

His spine is straight and not curved.

Casually showing off the brand-name label.

He is aggressive so he has a protective armband on his right arm. He wears a chain bracelet on the other. He has bony wrists.

A line from the shoulders to the arm shows his muscles. He also has thick shoulders.

Pointed elbows.

Punky earrings.

A thick neck. Muscles stick out of his neck. The chain necklace shows his roughness.

Lines showing his muscular chest. Wrinkles where his chest protrudes beneath the Tank-top.

Lines showing his muscular upper arms. He has broad shoulders. He looks wilder with a tattoo.

He doesn't wear a belt and deliberately has the top button of his pants undone. He is solid around the waist. Small buttocks.

Wrinkles showing the bulge of his thighs.

The shoelaces are drawn in realistic detail. He has big feet.

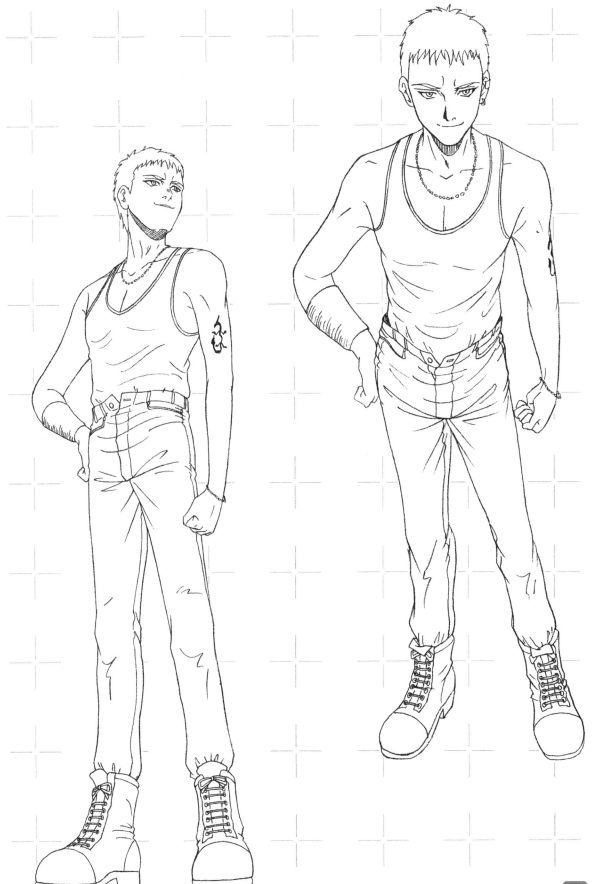

Real Type: Game Genre/Anti-heroine

Draw her a toned-down version of the Heroine and expose less her body. In the world of SF, the clothes are made out of stretchy material that show body contours. The outfit is designed with a **geometric pattern** of straight lines and circles. For the **body-hugging design**, it might be fun to exaggerate something that is fashionable now (but avoid trends that look as if they will be out of fashion within the year). Be bold in your designs without being bound by logic.

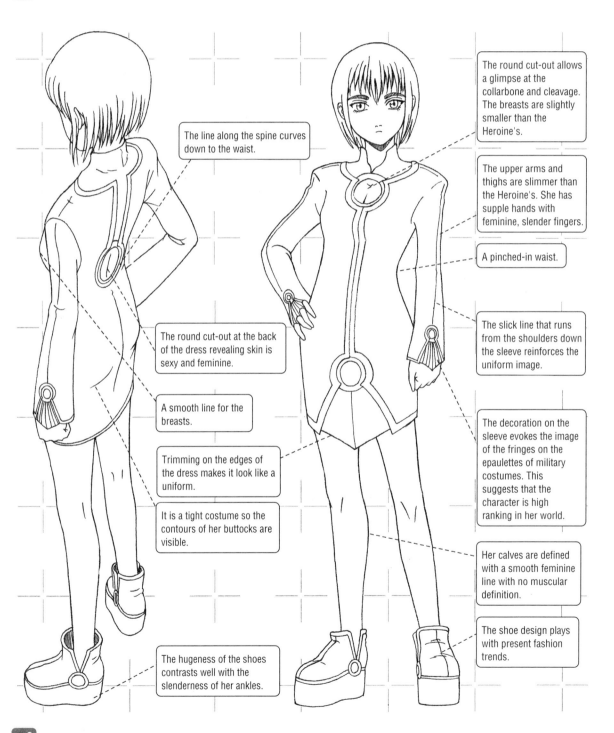

The line along the spine curves down to the waist.

The round cut-out allows a glimpse at the collarbone and cleavage. The breasts are slightly smaller than the Heroine's.

The upper arms and thighs are slimmer than the Heroine's. She has supple hands with feminine, slender fingers.

A pinched-in waist.

The round cut-out at the back of the dress revealing skin is sexy and feminine.

The slick line that runs from the shoulders down the sleeve reinforces the uniform image.

A smooth line for the breasts.

Trimming on the edges of the dress makes it look like a uniform.

The decoration on the sleeve evokes the image of the fringes on the epaulettes of military costumes. This suggests that the character is high ranking in her world.

It is a tight costume so the contours of her buttocks are visible.

Her calves are defined with a smooth feminine line with no muscular definition.

The shoe design plays with present fashion trends.

The hugeness of the shoes contrasts well with the slenderness of her ankles.

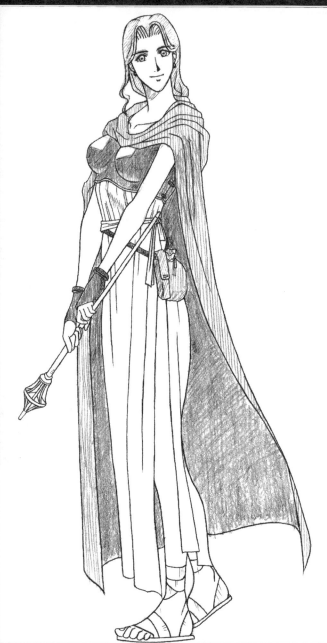

PROFILE
Name: Yasuyoshi Suzuki
Birthplace: Shizuoka Prefecture, Japan
Date of Birth: April 11th 1975
A graduate from technical college, Suzuki is now moving his way up in the world of Game graphic design.

I am working in Game graphic design. Although I don't really feel as if I am in a position to be handing out advice yet, I am glad to have this opportunity to advise would-be animators.

The first time I thought that I wanted to draw for a living was at junior high school, I suppose. The films and animation I watched and the manga novels I read at this tender age have had a big influence in getting me where I am now.

I have some points in mind when I draw for fun. That is, **I strive to perfect what I draw by doing fair copies of my drawings.** Of course I am not talking about rough sketches and doodles, but the other stuff I draw as close to perfection as I can. I do this because I find that when I redraw something that looks OK in rough, the ambiguity or distortions in the design stand out in bold relief.

And there is one other thing I want to say. **Show your work to others. You shouldn't keep your drawings to yourself.** People's evaluation can be a great stimulus. There are a lot of other things that I could say but I will leave you with these two main points.

If you really want to draw for a living then I advise you to make fair copies of your drawings and show people your drawings. I hope that this advice helps you to get to where you want to go.

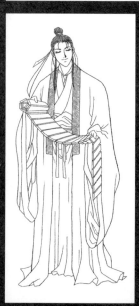

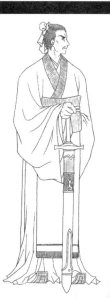

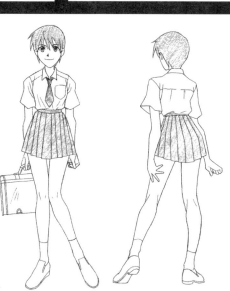

Chapter 4
Drawing Detail

Drawing Supporting Characters

So far you have looked at single characters (the leading characters) but an animation or manga work cannot be produced with just the one character. You must also have **a cast of supporting characters**.

So take a look at how to draw the essential cast of supporting characters. You have to express the individuality of each one with accuracy. There are two things that you must do: **make the leading characters stand out above the rest**, and endow the supporting characters with enough personality to make them interesting.

Think of **the personal background** (their past, their beliefs, their relationship with the leading character/s etc.) for each character and then convey this information in **the total design** through such things as their expressions, hairstyle, costume and accessories.

First, compare their height. The Hero is usually about 150 cm (5'00" ft.).

1. The Child	About 1 m (3'33" ft.)
2. The Hero/Heroine (Normal type)	About 150 cm (5'00" ft.)
3. The Stocky Middle-aged Man	About 140 cm (4'67" ft.)
4. The Strong Man	About 188 cm (6'27" ft.)
5. The Normal Middle-aged Man	About 180 cm (6'00" ft.)
6. The Older Woman	About 158 cm (5'27" ft.)
7. The Middle-aged Woman	About 140 cm (4'67" ft.)

2. The Hero/heroine

The height of the Normal type body is 7 times the length of the head. The legs are slightly longer than is realistic.

3. The Stocky Middle-aged Man

(In the Fantasy Genre works, this would be a dwarf, for example.)

1. The Child

The head is big compared to the body. Make sure that when you draw the child's expression you don't put an adult face on a child's body.

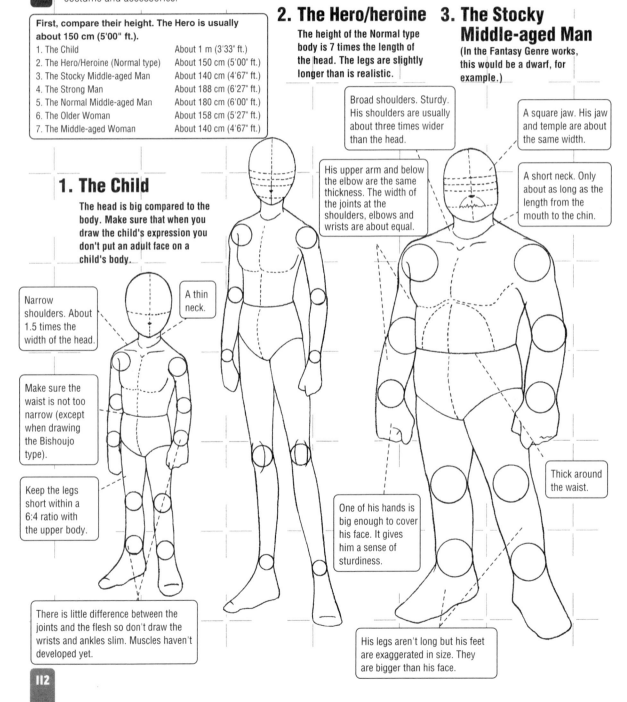

Broad shoulders. Sturdy. His shoulders are usually about three times wider than the head.

His upper arm and below the elbow are the same thickness. The width of the joints at the shoulders, elbows and wrists are about equal.

A square jaw. His jaw and temple are about the same width.

A short neck. Only about as long as the length from the mouth to the chin.

Narrow shoulders. About 1.5 times the width of the head.

A thin neck.

Make sure the waist is not too narrow (except when drawing the Bishoujo type).

Keep the legs short within a 6:4 ratio with the upper body.

Thick around the waist.

One of his hands is big enough to cover his face. It gives him a sense of sturdiness.

There is little difference between the joints and the flesh so don't draw the wrists and ankles slim. Muscles haven't developed yet.

His legs aren't long but his feet are exaggerated in size. They are bigger than his face.

Characters nos. 3 through 7 are all much more difficult to draw than the attractive leading & supporting characters as well as Bishoujo characters. Drawing older people realistically breaths life into your work and the characters.

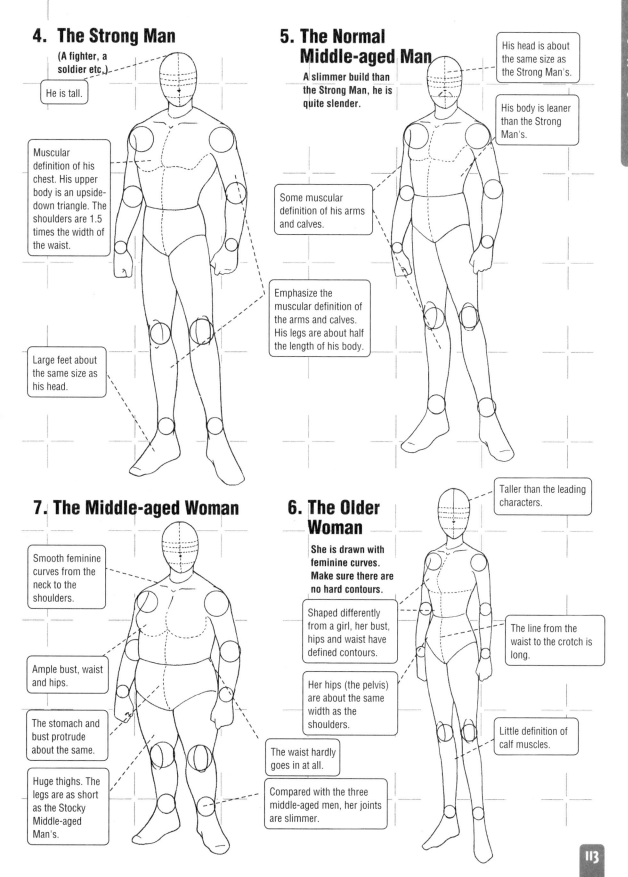

4. The Strong Man

(A fighter, a soldier etc.)

He is tall.

Muscular definition of his chest. His upper body is an upside-down triangle. The shoulders are 1.5 times the width of the waist.

Large feet about the same size as his head.

5. The Normal Middle-aged Man

A slimmer build than the Strong Man, he is quite slender.

His head is about the same size as the Strong Man's.

His body is leaner than the Strong Man's.

Some muscular definition of his arms and calves.

Emphasize the muscular definition of the arms and calves. His legs are about half the length of his body.

7. The Middle-aged Woman

Smooth feminine curves from the neck to the shoulders.

Ample bust, waist and hips.

The stomach and bust protrude about the same.

Huge thighs. The legs are as short as the Stocky Middle-aged Man's.

6. The Older Woman

She is drawn with feminine curves. Make sure there are no hard contours.

Shaped differently from a girl, her bust, hips and waist have defined contours.

Her hips (the pelvis) are about the same width as the shoulders.

The waist hardly goes in at all.

Compared with the three middle-aged men, her joints are slimmer.

Taller than the leading characters.

The line from the waist to the crotch is long.

Little definition of calf muscles.

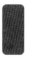

The Design of the Supporting Characters: Looking at Height
So far most of the leading characters have been introduced. This will help you figure out **what size you should draw the supporting characters in relation to the leading characters**.

The Heroes

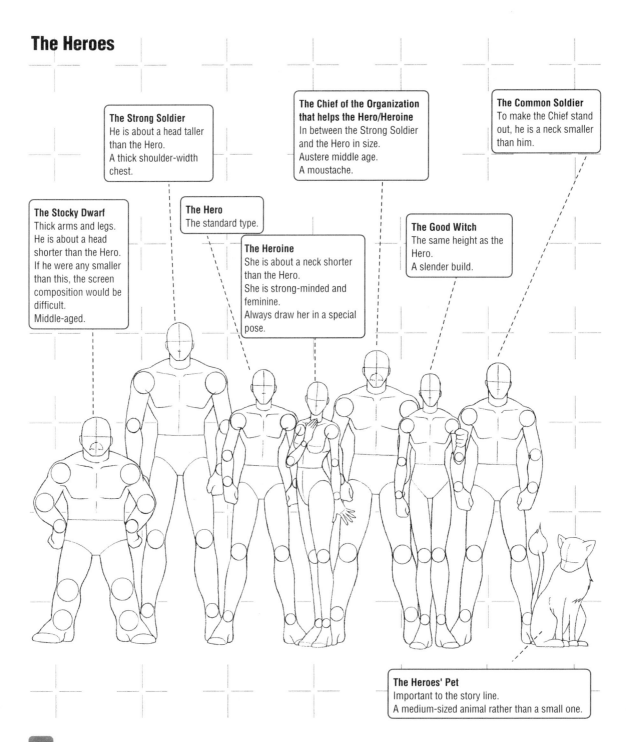

The Strong Soldier
He is about a head taller than the Hero.
A thick shoulder-width chest.

The Chief of the Organization that helps the Hero/Heroine
In between the Strong Soldier and the Hero in size.
Austere middle age.
A moustache.

The Common Soldier
To make the Chief stand out, he is a neck smaller than him.

The Stocky Dwarf
Thick arms and legs.
He is about a head shorter than the Hero.
If he were any smaller than this, the screen composition would be difficult.
Middle-aged.

The Hero
The standard type.

The Heroine
She is about a neck shorter than the Hero.
She is strong-minded and feminine.
Always draw her in a special pose.

The Good Witch
The same height as the Hero.
A slender build.

The Heroes' Pet
Important to the story line.
A medium-sized animal rather than a small one.

The Villains

The Enemy Chief
Stubborn.
His shoulders are narrower than the Strong Soldier's on the Goodies' side.

The Female Enemy Character
A domineering pose irrespective of the genre type.
A little taller than the Hero.

The Monster
Huge hands and feet to emphasize his strength.

The Enemy Adviser: The Bad Witch (Character 2)
The same size as the equivalent on the witch on the Goodies' side but she strikes a feminine pose.

The Enemy Adviser: The Sorcerer (Character 1)
An old man with a bent back

The Enemy Number 2
Half a head taller than the Hero but smaller than the Enemy Chief.
An attractive character

The Enemy Spy
Apish (Short with long arms)
Moves like a ninja.

The Villains' Pet
No particular meaning in the story.
In the story to emphasize the refinement of the devil.

Hairstyles have already been mentioned in the earlier chapter on individual characters, but they are different for every work. In each work, they must be designed **to set the particular story and the various personalities within it**.

The collection of hairstyles here is not definitive. **Heroes have unexpectedly conservative hairstyles**. Their hairstyles should be in tune with the expectations of their audience/readers, and to avoid the two extremes of their possible reaction, that is love and hate, strange hairstyles should be avoided. The hairstyles of the supporting characters are easy to decide, but the same is not true of the leading characters'. They must be **at the same time normal and striking**. Even a professional animation/manga artist spends quite some time coming to a decision on the matter.

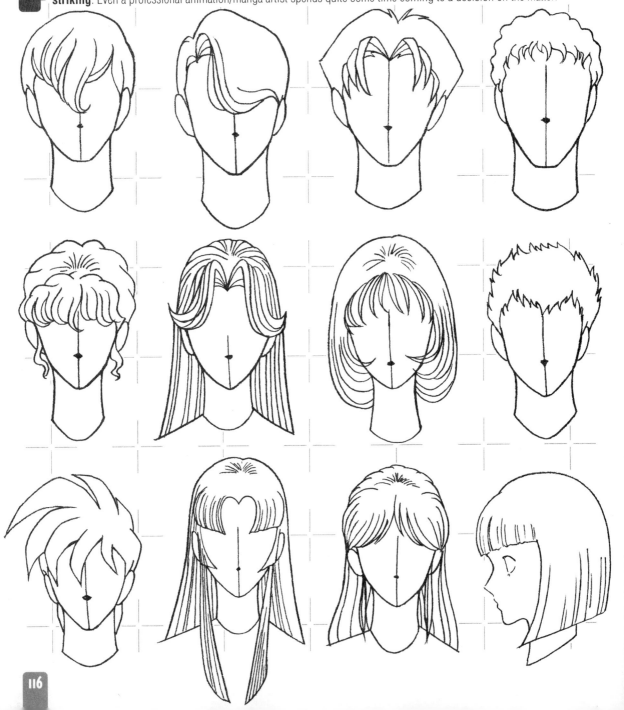

The thing that you must get right when drawing hair is not the shape of the hairstyle but **whether you are ready to apply the color**. Whether you are painting in the color by hand or using a computer, professionals **use lines to divide the hair into areas of different colors**.

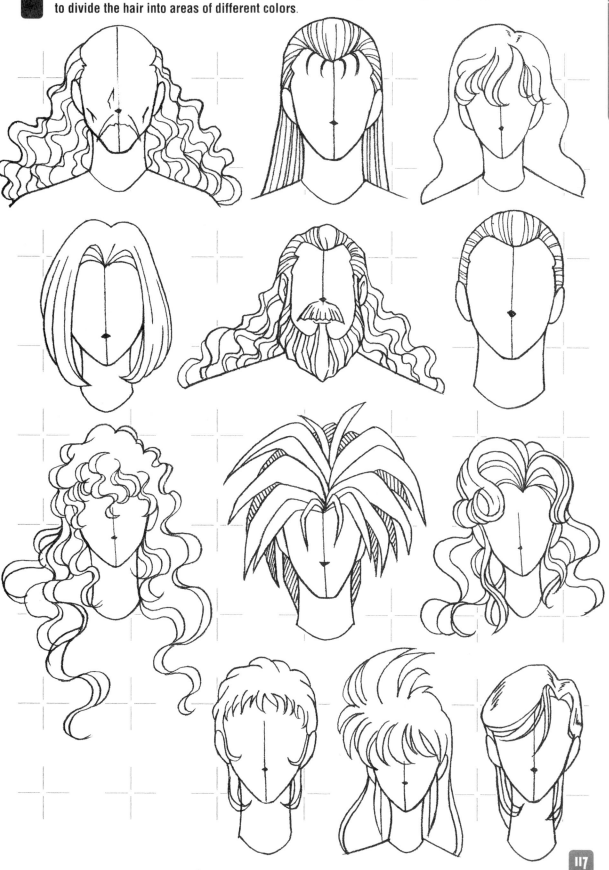

Amateurs start by drawing each strand of hair and finish with the outline for the entire head of hair.
The first thing a professional thinks of is **the entire outline**. Then he/she divides the hair into tufts by drawing lines.
Shading and applying different areas of colors are deliberate ways of changing tufts of hair and the shape. The important thing is to pick out shapes for hairstyles from your favorite works and pictures that you think are good, and start drawing them.

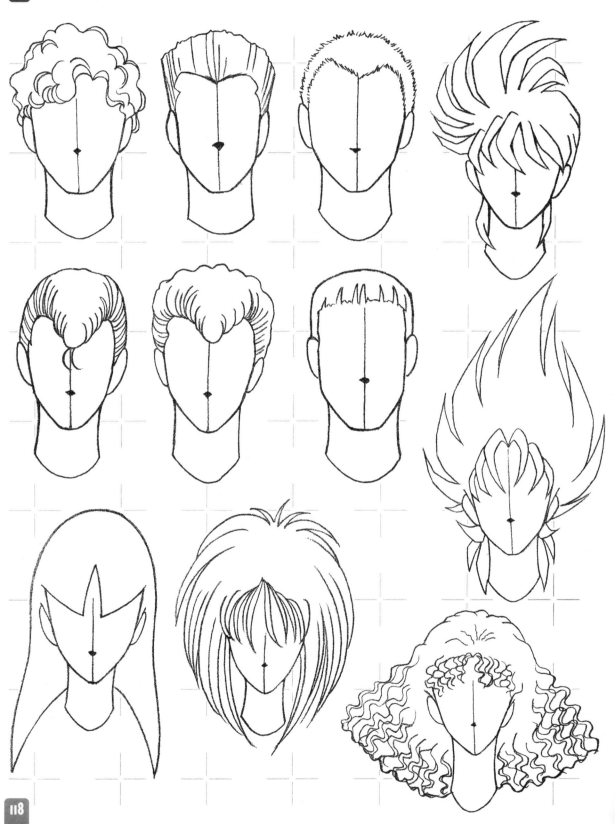

Practice Drawing Eyes.

First is the practice for drawing the eyes. As mentioned already, the design of the whole body is **subconscious information**. Although there are many people who say they like **the design of the eyes**, or the hairstyle, there aren't for **the sketch of the body (the physique)**. If the sketch of the body doesn't work though, this registers with people subconsciously and they end up thinking "I don't like this piece of work much."

Information immediately jumps out to us from eyes, whether they are the eyes of a living human being or a manga or animation character. This is what is called **conscious information**. The eyes are probably your greatest concern when you are drawing the character design. Perhaps you have tried to draw lots of eyes but to your surprise **the shape** always looks slapdash.

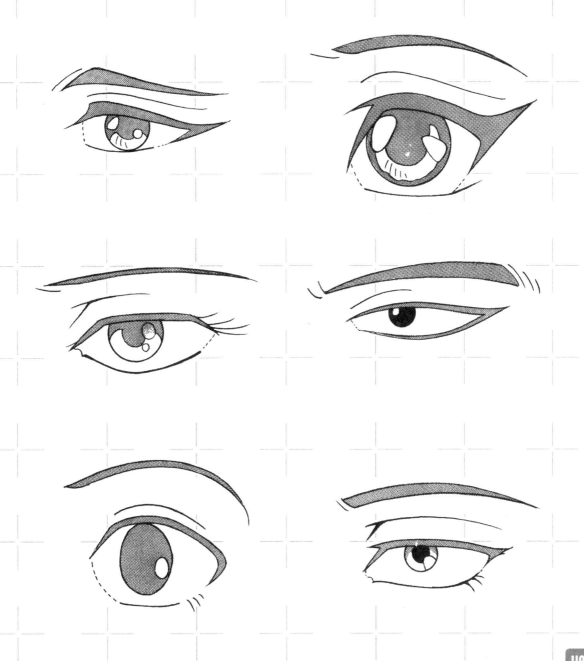

Here is some **information on the eyes that are often used in animation and manga**. It is meaningless to say which is the best design. The problem about eyes is that although you can draw them perfectly well face-on, you can't even draw the eyes you are best at drawing when the direction of the face or body changes. It is fun deciding things like the color/s of the pupils, the number of eyelashes, and whether the highlights should be round or square. But these considerations take over and you tend to forget the overall shape. **The biggest pitfall you can fall in** though is you can't draw the eyes when **the angle of the face** changes.

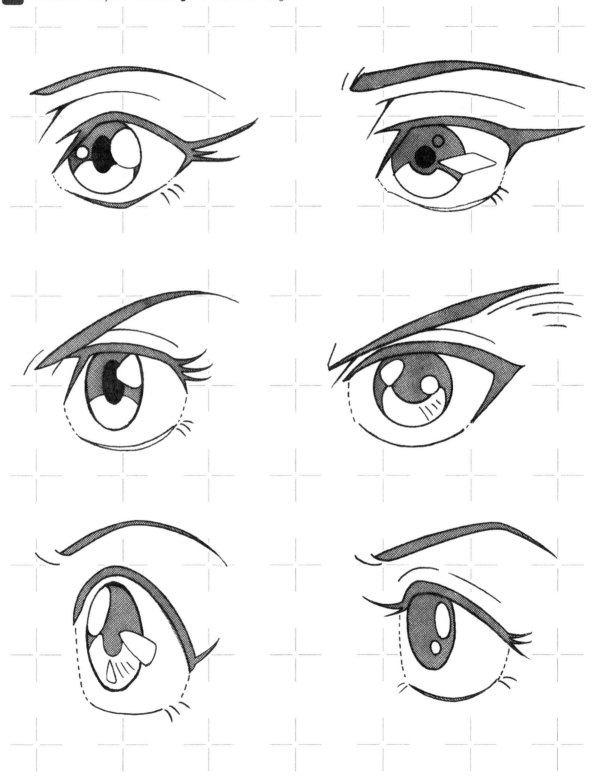

1: Start with the Outline

Here are some outlines for the eyes. Can you see that they are outlines of the eyes on the previous pages? Before you draw the details of the eyes, think that the people looking at your drawing will register this information subconsciously. Just as with the sketches of the body, the sketches of the eyes are also essential. With an awareness of their importance, think of it as a culmination of angles like the body. Look at the outlines below and work out how they are composed. For example, look at the shapes, the diamonds, triangles and curves, in the outline.

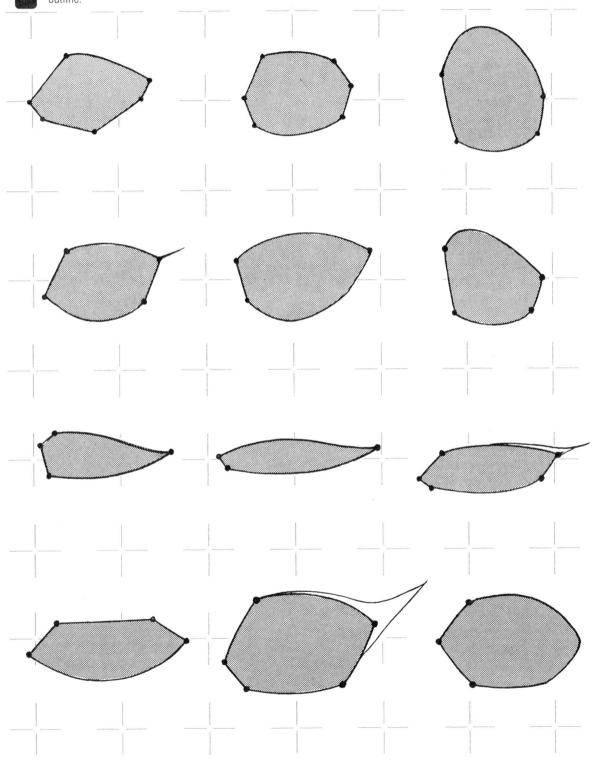

2: Stick on the polygons

Try **sticking the outlines for the eyes onto part of the full-face** that is considered a polygon (a square box). Decide the position for the eyes without being led astray by considerations such as the number of eyelashes or the shape of the highlights. Naturally when the angle changes, draw **the outlines for the eyes as they were one side of a polygon**. They are not that difficult to draw if you draw think of them in the same way as you would a box.

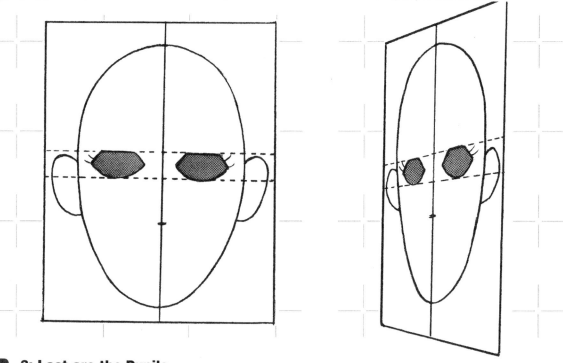

3: Last are the Pupils

Once the angle has been decided and you have drawn the outline, you can start the job of drawing in the pupils. Actually this is where "think in polygons" evolves into **"think in curves."** Make sure you master drawing the pupils on a flat surface first.

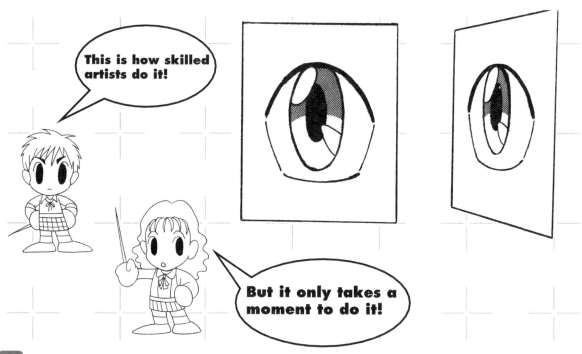

Practice Drawing Feet.

Hands and feet are difficult to draw because they are very complicated. The first step is to draw them as cubes.

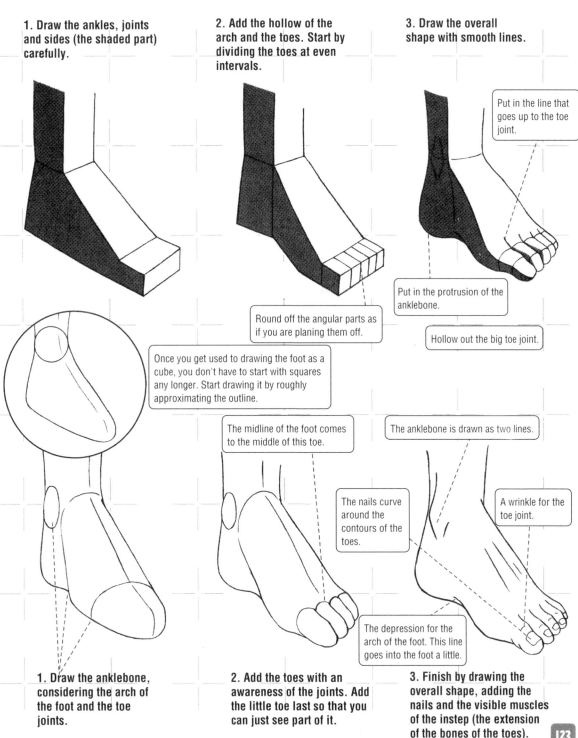

1. Draw the ankles, joints and sides (the shaded part) carefully.

2. Add the hollow of the arch and the toes. Start by dividing the toes at even intervals.

3. Draw the overall shape with smooth lines.

Put in the line that goes up to the toe joint.

Put in the protrusion of the anklebone.

Round off the angular parts as if you are planing them off.

Hollow out the big toe joint.

Once you get used to drawing the foot as a cube, you don't have to start with squares any longer. Start drawing it by roughly approximating the outline.

The midline of the foot comes to the middle of this toe.

The anklebone is drawn as two lines.

The nails curve around the contours of the toes.

A wrinkle for the toe joint.

The depression for the arch of the foot. This line goes into the foot a little.

1. Draw the anklebone, considering the arch of the foot and the toe joints.

2. Add the toes with an awareness of the joints. Add the little toe last so that you can just see part of it.

3. Finish by drawing the overall shape, adding the nails and the visible muscles of the instep (the extension of the bones of the toes).

123

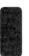

Aspects of Feet: Variation 1

The sole of the foot is used in quite a lot of scenes such as when the character is kneeling or sitting cross-legged, or kicking face-on in an action scene. Practice drawing the following poses.

Aspects of Feet: Variation 2
The following are a collection of common aspects of the feet and the less common twist.

Common Aspects

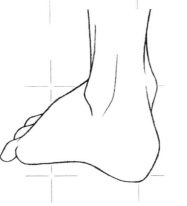

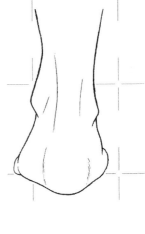

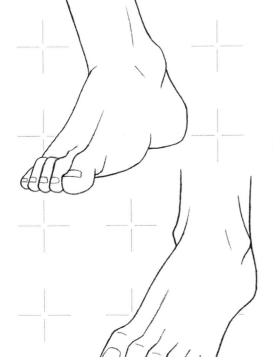

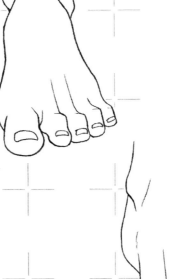

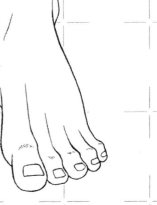

The Twist •

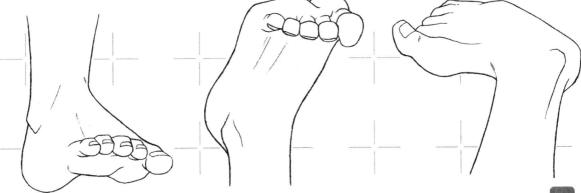

Practice Drawing Hands

The hand is the best barometer of human being's evolutionary advancement. Chimpanzees and gorillas have the manual dexterity to hold things, but they are far inferior to men.

What makes drawing fingers so difficult is that each finger has several joints, all of which are different lengths. The quickest way to improve is to practice sketching your own hand. Another effective method would be to copy drawings that make you think **"How on earth did they manage to draw that at such a difficult angle?"**

1. Draw the wrist, the joints at the back of the hand and the sides (the shaded part) carefully.

2. Imagine how each joint and finger looks like. The little finger looks different from the others. Check by looking at your own fingers.

3. Change the overall shape of the hand from cubic to cylindrical. Do this for details such as the fingers that include the joints at the back of the hand, and the thickness of the palm too.

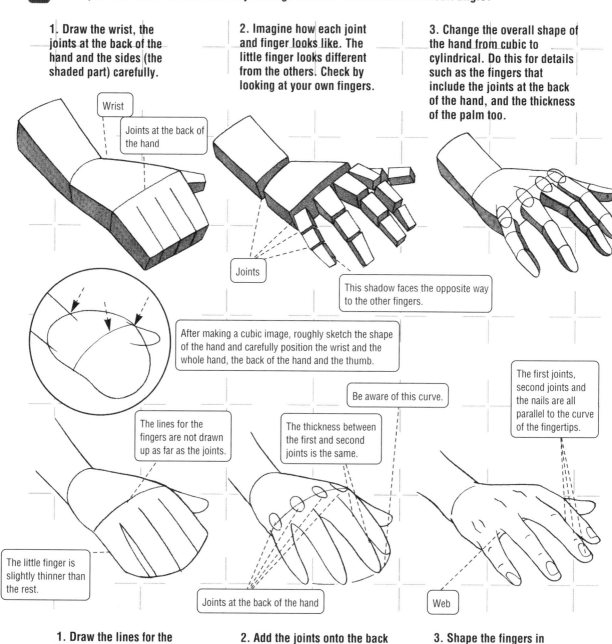

Wrist

Joints at the back of the hand

Joints

This shadow faces the opposite way to the other fingers.

After making a cubic image, roughly sketch the shape of the hand and carefully position the wrist and the whole hand, the back of the hand and the thumb.

The lines for the fingers are not drawn up as far as the joints.

The thickness between the first and second joints is the same.

Be aware of this curve.

The first joints, second joints and the nails are all parallel to the curve of the fingertips.

The little finger is slightly thinner than the rest.

Joints at the back of the hand

Web

1. Draw the lines for the fingers. Imagine how they will look and draw the little finger slightly apart from the rest.

2. Add the joints onto the back of the hand, and shape the fingers. The thickness between the first and second joints is the same, but the fingers taper from The thumb angles outwards.shaped.

3. Shape the fingers in more detail, drawing the protrusion of the joints, the nails and the webs

Aspects of Hands: Variations

The following are a collection of common aspects of the hands. Practice so that you can draw the poses for both the right and left hands.

Clenched

Open ·

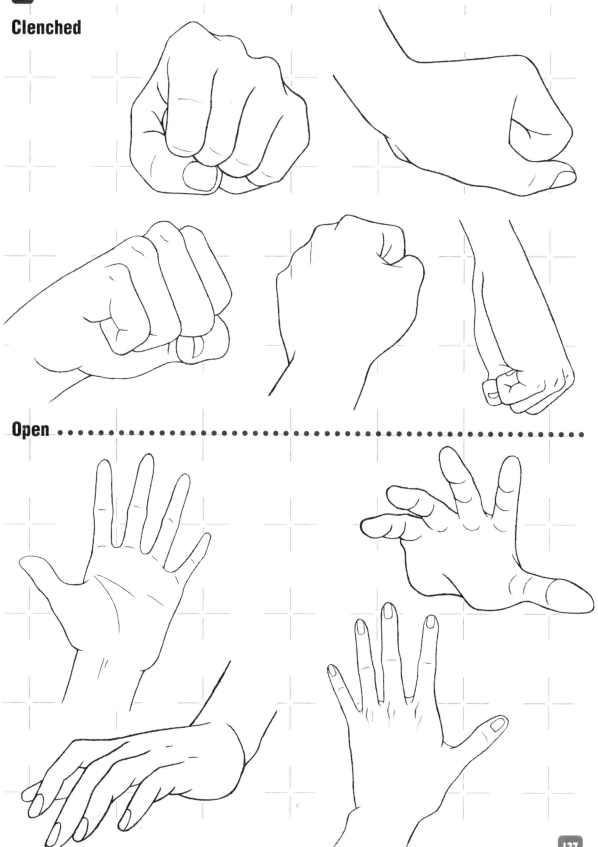

Meaningful poses

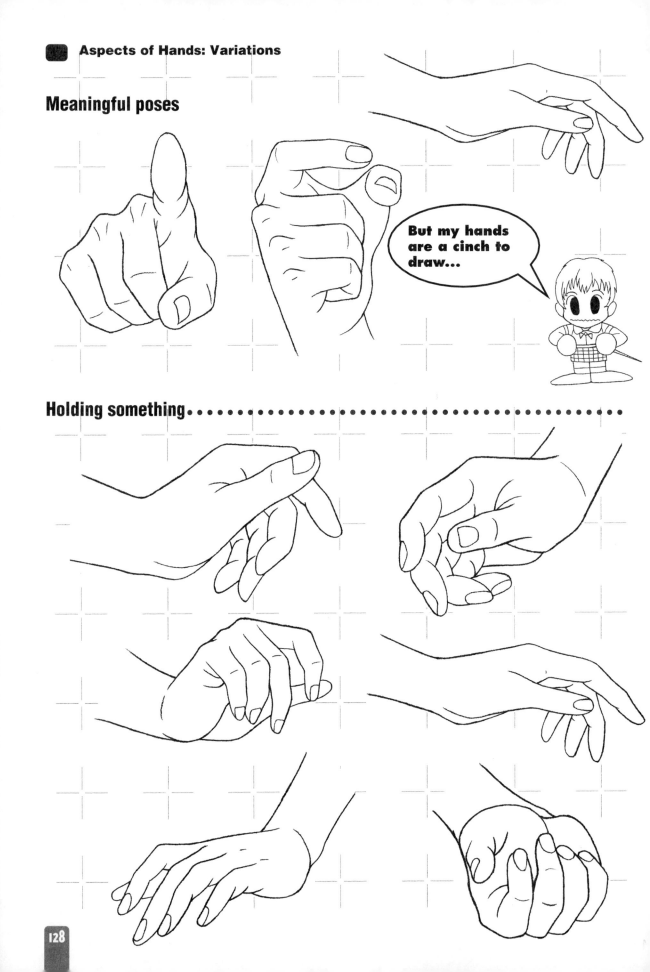

But my hands are a cinch to draw...

Holding something..

Create a scene! Character Arrangement and the Scene

Create **a scene of multiple characters that is relevant to the story**. This is the most interesting part of the process. You are like **a film director** telling your original characters where you want them. Have you ever wondered if you are managing to make people feel what you intended to convey through your work? The following introduces **the professional's approach to arranging characters** and its influences on the scene. Do not assume that this is a definitive catalogue of possible scenes but use it as a source of reference.

Fantasy and Magic

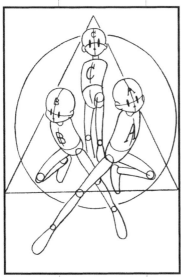

Fencer A is thrusting forward his sword; **Fighter B** is thrusting his/her fist; and **Sorcerer C** is holding his magic wand above his head. This is a composition of lively poses with all the characters moving outwards from the center.

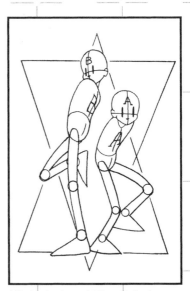

A lively adventure unfolding with **the duo Fencer A and Magician B**. The layout shows the movement of the two leading characters. Note that the overall outline is star-shaped.

A child-witch story. Heroine A is living her life as an elementary school student. She uses her magic powers to change into 20-year-old Person B. The layout shows a large shot of A breast-upwards with B full-sized in front.

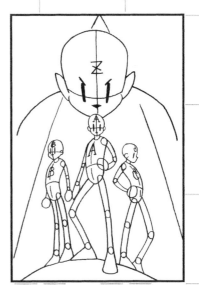

A ninja action story. The leading characters A, B and C fight using the skills of stealth and secrecy practiced by the ninja. They are joining forces to fight Enemy King Z. The layout showing Z looming menacingly over A, B and C evokes a feeling of oppression.

Hero stories

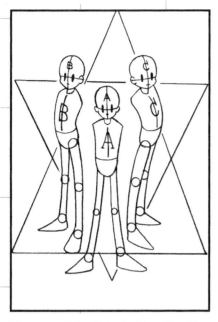

A threesome with A as the leader. A is positioned in the center in what is the most common pose. **A standard composition.**

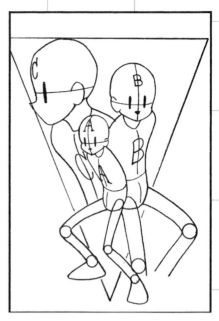

A story unfolds involving a threesome comprising of **Hero A, Rival B and Heroine C**. In the layout, the further the characters are the larger they become; A is full-size, B medium-size and C is shown breast-upwards.

Sports stories

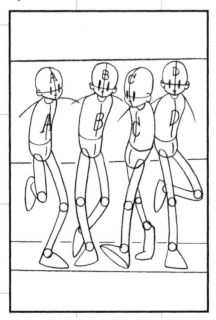

C is the Hero who plays Forward for the **high school soccer team**. In the match C has just got a goal and his team-mates are converging to congratulate him. Each character moves in response to the situation and, even though they are in one horizontal line, the layout effectively expresses movement.

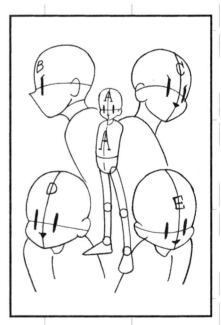

Hero A is a sportsman with his rivals (B, C, D and E). The story is **the battle** that unfolds between them. In the layout, A is full-sized in the center surrounded by the sub-characters shot breast-upwards.

The Group (Organization)

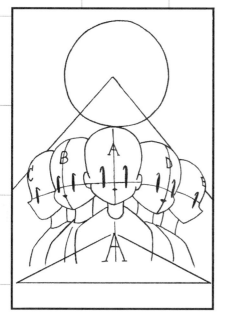

A detective story. A is a dangerous cop with 20 years of experience in the force. He works with B who is in his tenth year on the force, the new guy C, Woman D who has five years of experience but is still young, and E who has had over 30 years experience. Seen from above, the layout of the five characters shot breast-upwards is triangular.

A fight story. Fighter A is a student who never loses a fight. The others are Heroine B who goes to the same school (actually a fighter), Kendo Team Captain C, D on the judo team, E on the karate team, and F on the Sumo team etc. It is a fight that unfolds on the school grounds involving the various different fighting techniques. It is a complicated composition with a star-shaped layout of the group of ten characters in a deep perspective.

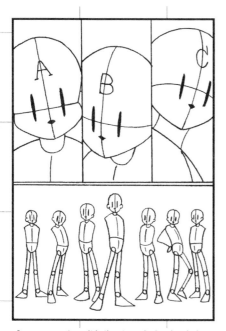

A pop group story. It is the story of a boy band of seven members. The Hero D is at center bottom. In the top half, there are large frames of the Hero's Younger Sister A, the Hero's Girlfriend B and his Manager C. The story unfolds around several incidents involving the 3 characters connected to the Hero. The screen is divided into two with separate close ups of each of the 3 characters in the top half.

A saga. Hero/Heroine A has ambitions to unify the world and B is helping him/her. C is positioned to fight against the Enemy. Often the cast of leading characters is quite complicated (for example, even a character on the Enemy side can be loved by the audience and therefore should be classed a Hero/ine). The arrangement of characters make a triangular outline with A at the base.

SF Stories

A futuristic SF story. Android A is the Hero who has lost his/her memory and Android B knows about A's past. The layout shows A medium-sized and B full-sized. Think of the composition as a circle and triangle.

A slapstick action story involving twin Heroes A and B in outer space. (But there is more to it than just laughs.) The layout shows the two Heroes sitting back to back and front-facing.

Love Stories

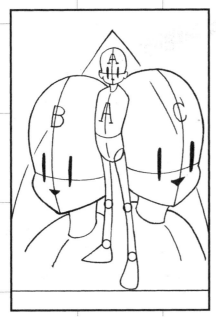

A love story. A 17-year-old boy meets an old female classmate B after ten years. But A already has girlfriend C. A love triangle unfolds. A is standing in the center with close ups of the faces of B and C on either side.

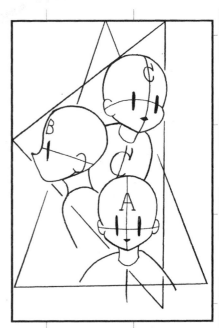

A love story. An omnibus love story involving three girls A, B and C. All three characters, shown breast-upwards, have their faces looking in different directions.

Once you can draw the main compositions featured in the book, you will want to draw your own characters from any angle. It would be a real shame when you get to the layout stage for your story and think "I'd like to do that, but I can't draw characters' faces looking in different directions..." and you end up giving up, wouldn't it? So use the drawings below to practice drawing the face from slightly different angles. Once you can do this, you are ready to create your own animation and game.

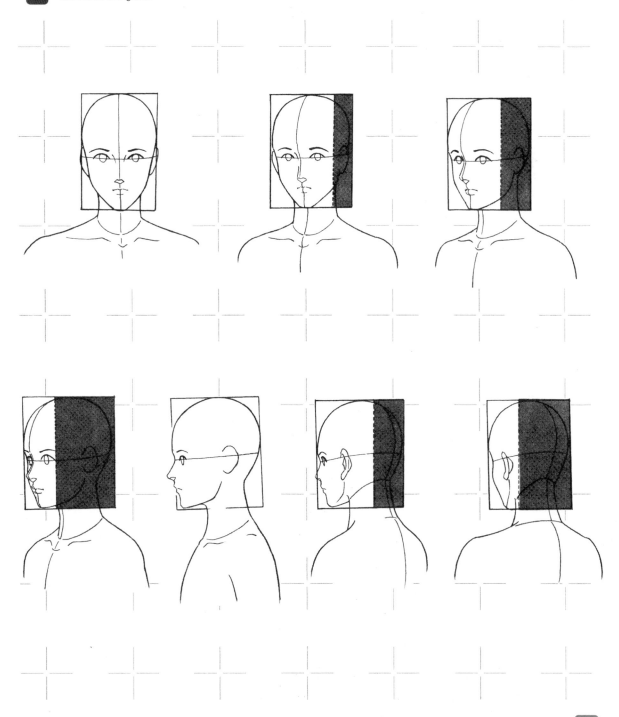

Lastly, here are pieces of work by students of animation and manga. Alongside the students' work there are professional critiques and the revised versions. These should help you see what kind of things to look out for when you are drawing your own characters.

Compare these with your drawings!

Checklist

- The protective guard is dubious in design and does not look three-dimensional. Change the design and use shading to make it look three-dimensional.
- The weapon looks flimsy. The shape should be modified. Draw it with bold lines to make it appear hard and heavy.
- The hair and clothes don't look right. Sharpen the outline and draw some wrinkles in the clothes.
- The pose is unbalanced. With the protective guard and weapon in his right hand, the weight looks to be too much to the right. Correct this and draw the character standing firm.

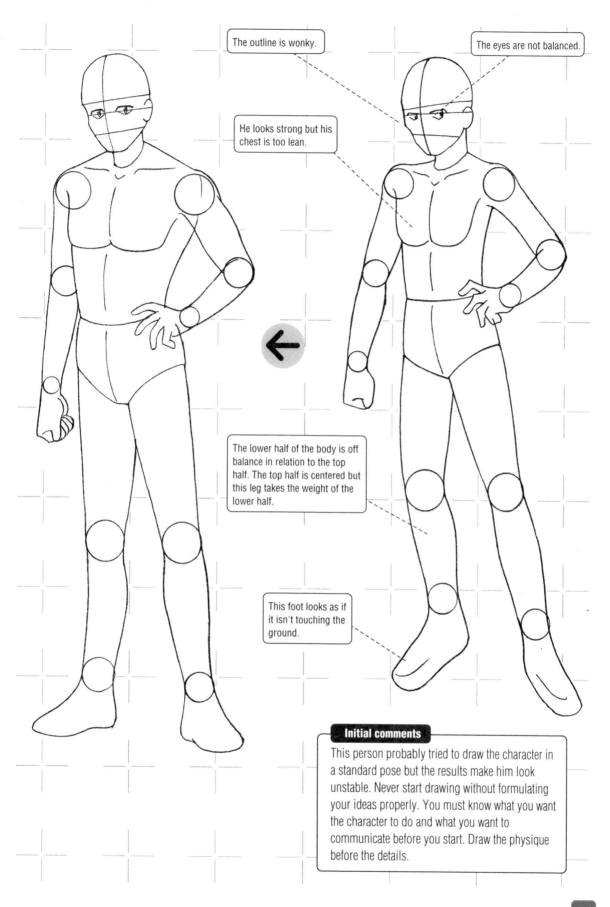

The outline is wonky.

The eyes are not balanced.

He looks strong but his chest is too lean.

The lower half of the body is off balance in relation to the top half. The top half is centered but this leg takes the weight of the lower half.

This foot looks as if it isn't touching the ground.

Initial comments

This person probably tried to draw the character in a standard pose but the results make him look unstable. Never start drawing without formulating your ideas properly. You must know what you want the character to do and what you want to communicate before you start. Draw the physique before the details.

Checklist

- The feet are sketched too roughly. Draw them in more detail.
- Her arms look bare so draw some bracelets.
- Make the pattern of the dress curve over her breast and hips.
- The dress is not drawn in enough detail.
- The folds at the hem of the dress don't look right. Draw the folds properly at even intervals.

Initial comments

The character's center of gravity is out (See Example 1) and she looks unstable. It is important to consider how the character fits into the scene and how he/she appears. Make sure you have this sorted out before you start drawing the details. If you don't, then you will end up conveying the wrong information. For instance, look at the character below. The revised version has the character standing in a confident pose, but the original looks restless as if she is hiding something, doesn't she?

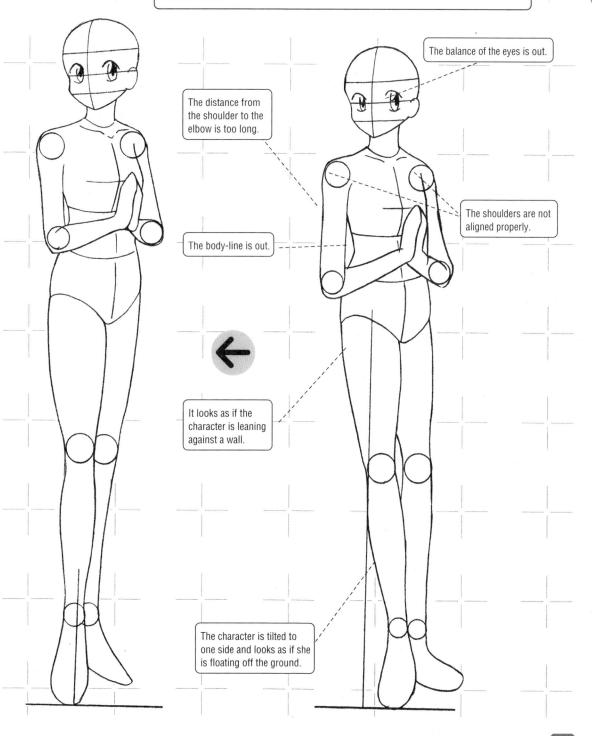

The balance of the eyes is out.

The distance from the shoulder to the elbow is too long.

The shoulders are not aligned properly.

The body-line is out.

It looks as if the character is leaning against a wall.

The character is tilted to one side and looks as if she is floating off the ground.

A Critique: Example 3

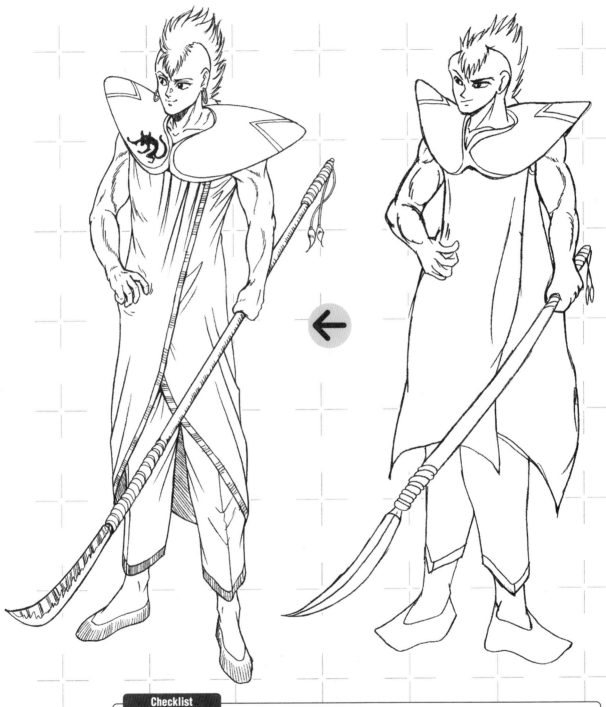

Checklist

- The legs look strange so draw the physique again from scratch.
- The clothes are designed in an original way so take time to develop the design further and draw it in more detail.
- The muscular definition is about right, but it would look more realistic if the muscles were drawn with many strokes instead of a single line.

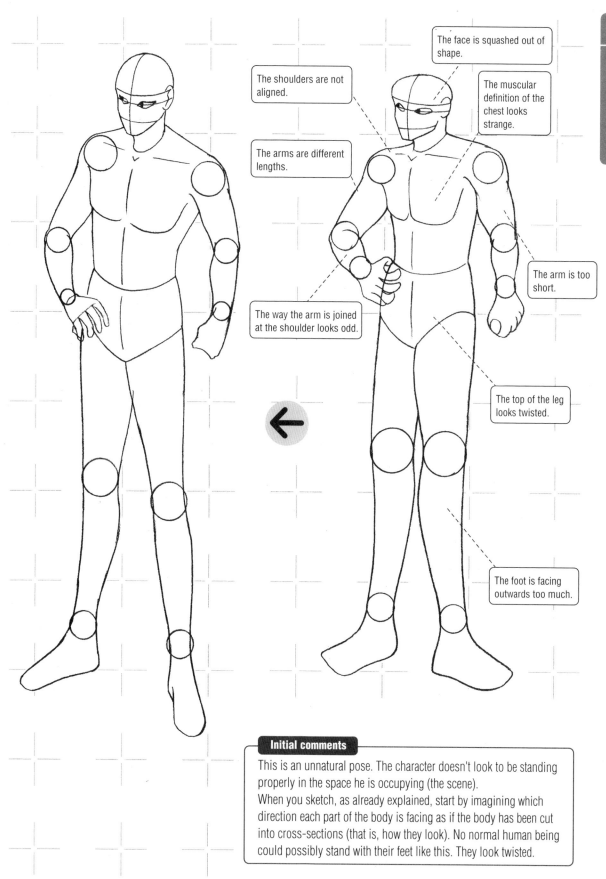

The shoulders are not aligned.

The arms are different lengths.

The face is squashed out of shape.

The muscular definition of the chest looks strange.

The arm is too short.

The way the arm is joined at the shoulder looks odd.

The top of the leg looks twisted.

The foot is facing outwards too much.

Initial comments

This is an unnatural pose. The character doesn't look to be standing properly in the space he is occupying (the scene).
When you sketch, as already explained, start by imagining which direction each part of the body is facing as if the body has been cut into cross-sections (that is, how they look). No normal human being could possibly stand with their feet like this. They look twisted.

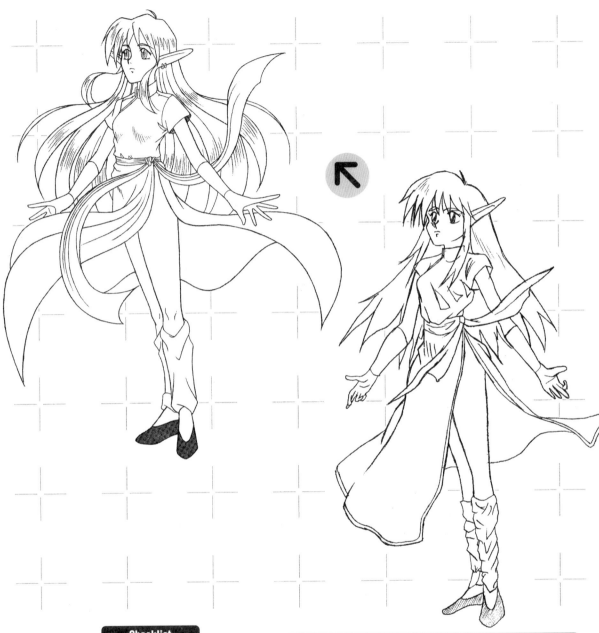

Checklist

- The face arrangement is basically fine although some minor adjustments need to be made.
- Definitely draw in the right ear even though only a tiny bit will be visible.
- Practice drawing the hand and fingers.
- Take care with the clothes' design. The right breast is defined but it looks as if she hasn't got a left one. Use shading to define both breasts.
- Be audacious and soften the movement of the hair and clothes fluttering in the breeze.
- If you shade in the inside of the sleeves, the material won't look paper-thin.
- It would be better to put highlights in this character's hair. Also, it looks dry and dishevelled unless the hair is separated into several bunches.
- Too many wrinkles in the legwarmers.

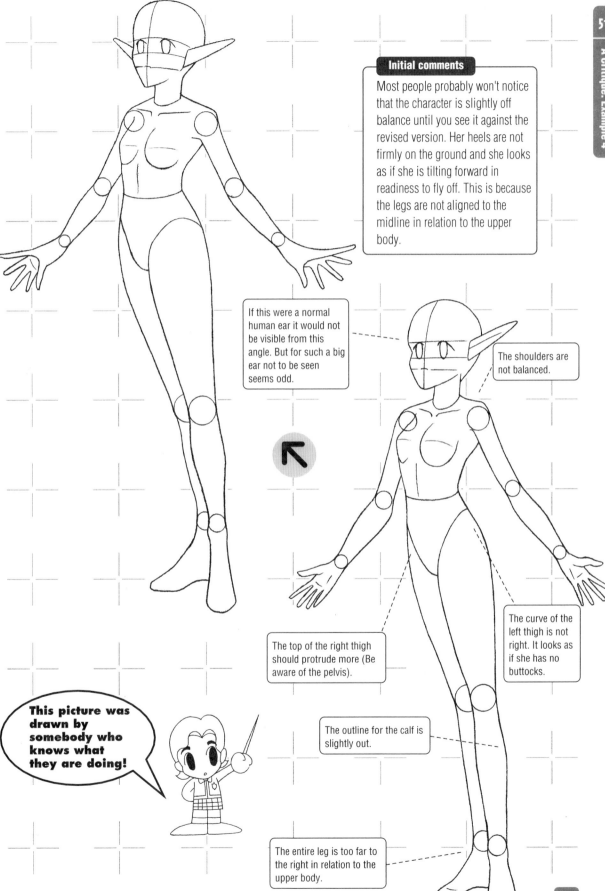

Initial comments

Most people probably won't notice that the character is slightly off balance until you see it against the revised version. Her heels are not firmly on the ground and she looks as if she is tilting forward in readiness to fly off. This is because the legs are not aligned to the midline in relation to the upper body.

If this were a normal human ear it would not be visible from this angle. But for such a big ear not to be seen seems odd.

The shoulders are not balanced.

The curve of the left thigh is not right. It looks as if she has no buttocks.

The top of the right thigh should protrude more (Be aware of the pelvis).

The outline for the calf is slightly out.

This picture was drawn by somebody who knows what they are doing!

The entire leg is too far to the right in relation to the upper body.

A Critique: Example 5

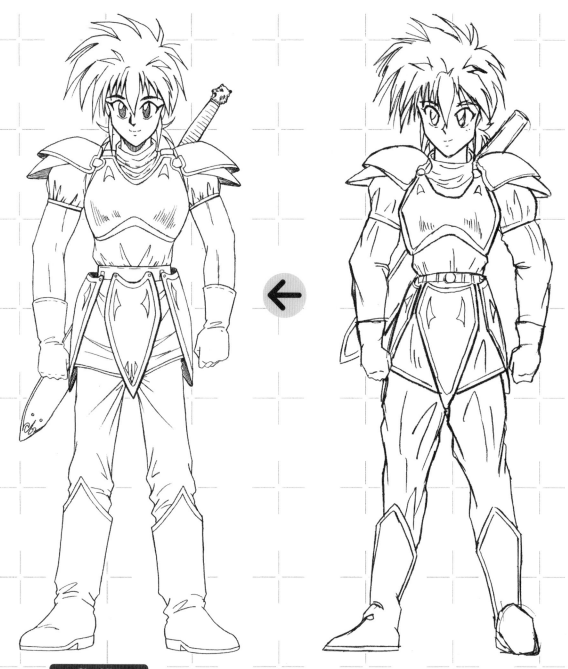

Checklist

- Make the nose look more three-dimensional.
- The suit of armor doesn't look three-dimensional, or that he is actually wearing it. Make it look more three-dimensional by drawing the contours and shading.
- There are too many inappropriate wrinkles in the clothes and there are none where there should be. With this type of character, drawing a well-defined outline is more important than concentrating on the wrinkles.
- The sword on his back is obscure. Pay more attention to it because it is this character's symbol.

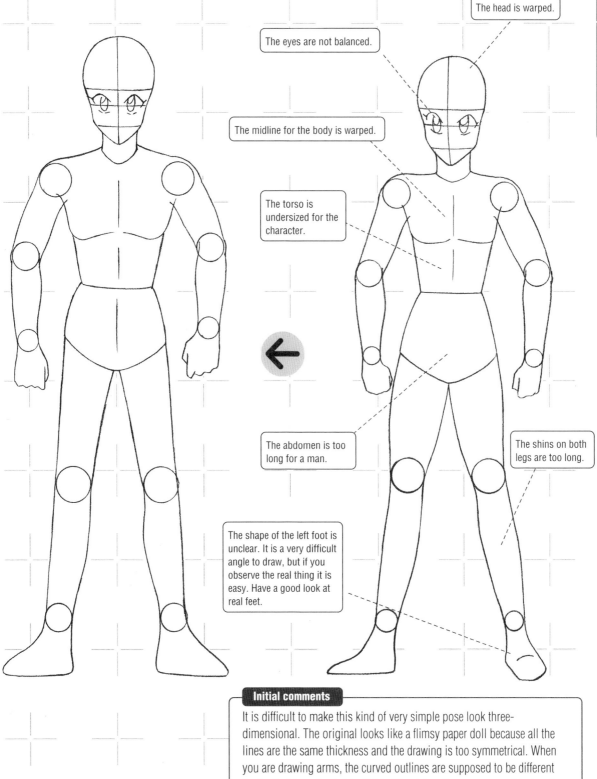

The head is warped.

The eyes are not balanced.

The midline for the body is warped.

The torso is undersized for the character.

The abdomen is too long for a man.

The shins on both legs are too long.

The shape of the left foot is unclear. It is a very difficult angle to draw, but if you observe the real thing it is easy. Have a good look at real feet.

Initial comments

It is difficult to make this kind of very simple pose look three-dimensional. The original looks like a flimsy paper doll because all the lines are the same thickness and the drawing is too symmetrical. When you are drawing arms, the curved outlines are supposed to be different for the inside and outside. But in this picture they are symmetrical and any sense of realism is lost. Try and erase from your mind the preconception that "Legs are thicker than arms, and thighs thicker than calves." In a muscular man like this character, the thickest part of his calves would be about the same thickness as his thighs.

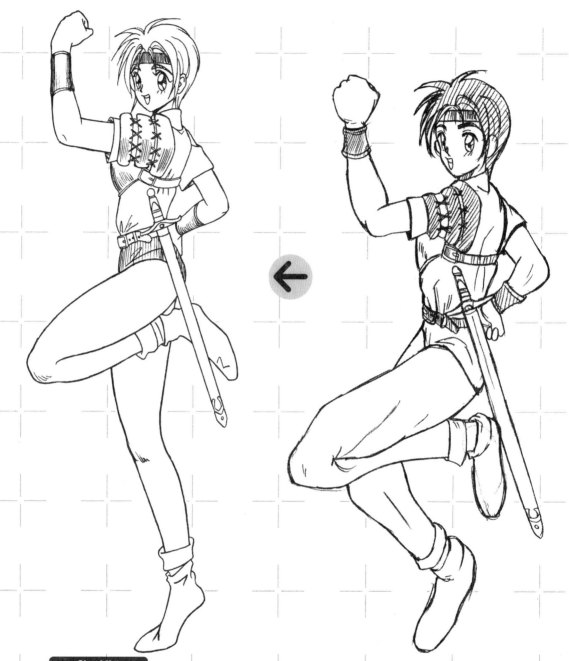

Checklist

- Meaningless lines are drawn on the thighs and calves. No matter how athletic she is, this is overdoing it.
- Take care with the directions of the arms and the back of the hand. Pose in front a mirror to look at how certain poses would look.
- Compared with the upper body, the lower body is too sparse in detail. You need to draw with more feeling for the subject. Don't draw pointed fold lines.
- If you color the fringe that falls over the face, it looks too heavy. It would be better to divide the hair up and have it sticking out.
- Draw this pose bolder because the original one doesn't go all the way.

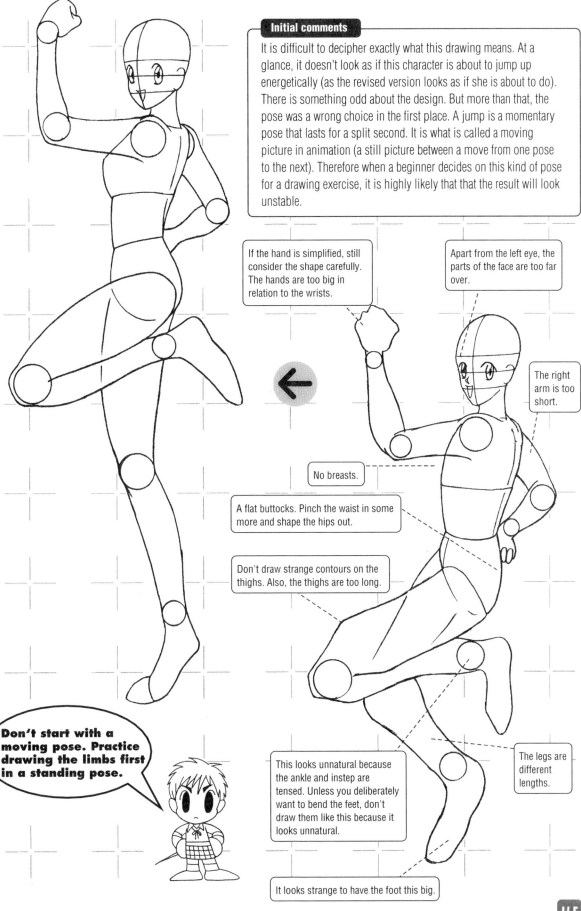

Initial comments

It is difficult to decipher exactly what this drawing means. At a glance, it doesn't look as if this character is about to jump up energetically (as the revised version looks as if she is about to do). There is something odd about the design. But more than that, the pose was a wrong choice in the first place. A jump is a momentary pose that lasts for a split second. It is what is called a moving picture in animation (a still picture between a move from one pose to the next). Therefore when a beginner decides on this kind of pose for a drawing exercise, it is highly likely that that the result will look unstable.

If the hand is simplified, still consider the shape carefully. The hands are too big in relation to the wrists.

Apart from the left eye, the parts of the face are too far over.

The right arm is too short.

No breasts.

A flat buttocks. Pinch the waist in some more and shape the hips out.

Don't draw strange contours on the thighs. Also, the thighs are too long.

The legs are different lengths.

Don't start with a moving pose. Practice drawing the limbs first in a standing pose.

This looks unnatural because the ankle and instep are tensed. Unless you deliberately want to bend the feet, don't draw them like this because it looks unnatural.

It looks strange to have the foot this big.

A Critique: Example 7

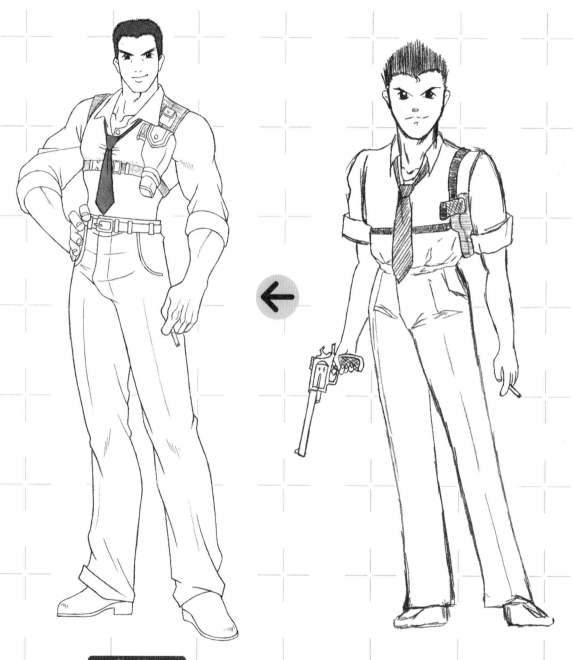

Checklist

- It looks as if the character holding something was a second thought. If you want to use objects to enhance the character's individualism, then more planning is necessary.
- It is unnatural to hold a gun in the right hand when there is already one in the gun holster. It is really difficult to draw someone holding a gun, so just draw it sitting in the holster.
- The hairstyle is rather obscure. Draw a more distinct style.
- The holster and the belt have not been drawn in enough detail. The holster in particular is an important accessory so make sure you draw it more carefully.

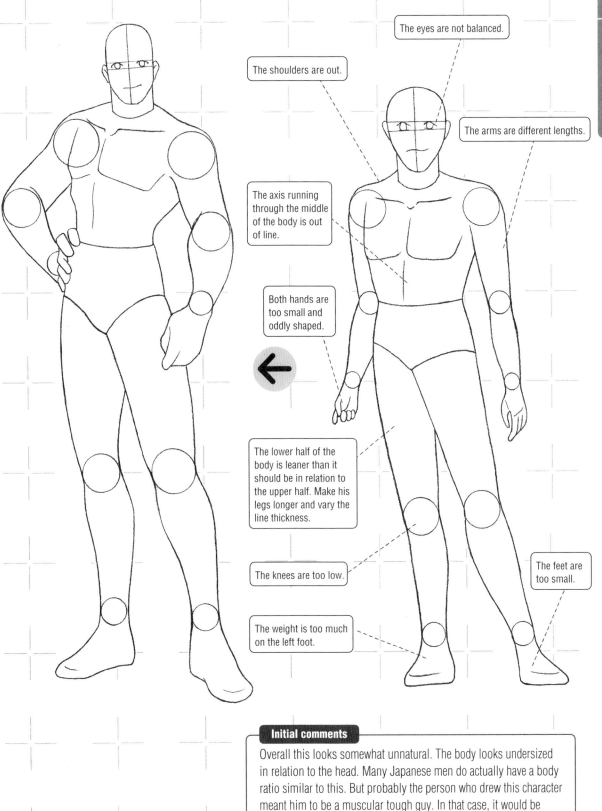

The eyes are not balanced.

The shoulders are out.

The arms are different lengths.

The axis running through the middle of the body is out of line.

Both hands are too small and oddly shaped.

The lower half of the body is leaner than it should be in relation to the upper half. Make his legs longer and vary the line thickness.

The knees are too low.

The feet are too small.

The weight is too much on the left foot.

Initial comments

Overall this looks somewhat unnatural. The body looks undersized in relation to the head. Many Japanese men do actually have a body ratio similar to this. But probably the person who drew this character meant him to be a muscular tough guy. In that case, it would be better to draw the height of the body 9 times the length of the head, and the shoulders three times its width of the head.

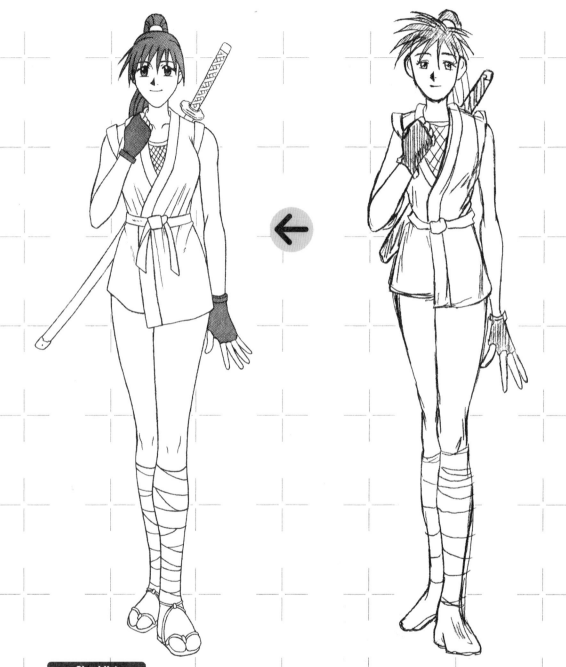

Checklist

- Essentially straps come round the front to fasten the sword. But they are omitted because they would look oppressive.
- Don't just draw the sword willy-nilly. It is an important object.
- The hair looks thin. There is this kind of spiky hairstyle but the revised version looks more composed.
- An obscure expression on her face. You can't tell if she is happy or sad. This type of character clearly has one or the other. It would be unnatural for her to have a sad expression when standing in such a strong courageous pose.
- There are no ends of the obi. The bleached cotton or gaiters wrapped around her legs are not drawn properly.

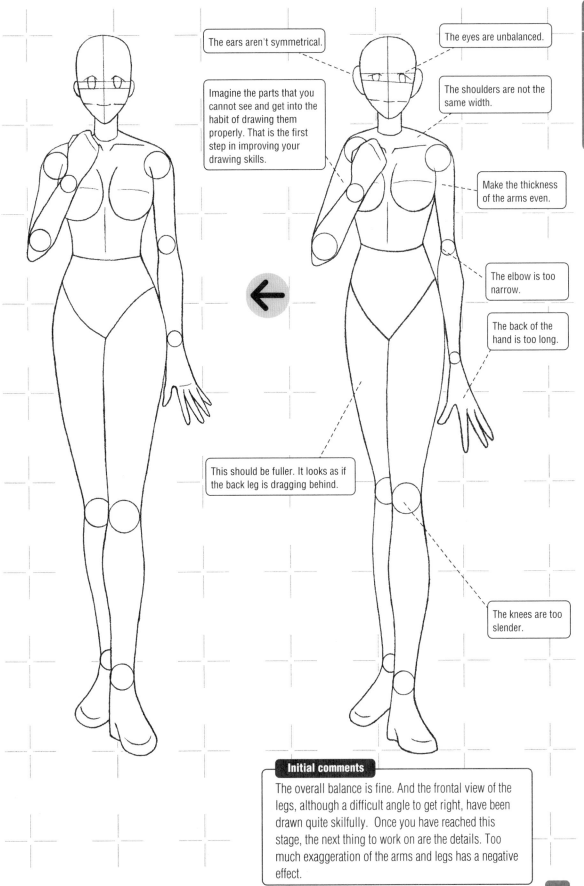

The ears aren't symmetrical.

The eyes are unbalanced.

Imagine the parts that you cannot see and get into the habit of drawing them properly. That is the first step in improving your drawing skills.

The shoulders are not the same width.

Make the thickness of the arms even.

The elbow is too narrow.

The back of the hand is too long.

This should be fuller. It looks as if the back leg is dragging behind.

The knees are too slender.

Initial comments

The overall balance is fine. And the frontal view of the legs, although a difficult angle to get right, have been drawn quite skilfully. Once you have reached this stage, the next thing to work on are the details. Too much exaggeration of the arms and legs has a negative effect.

Finding the Best Pose

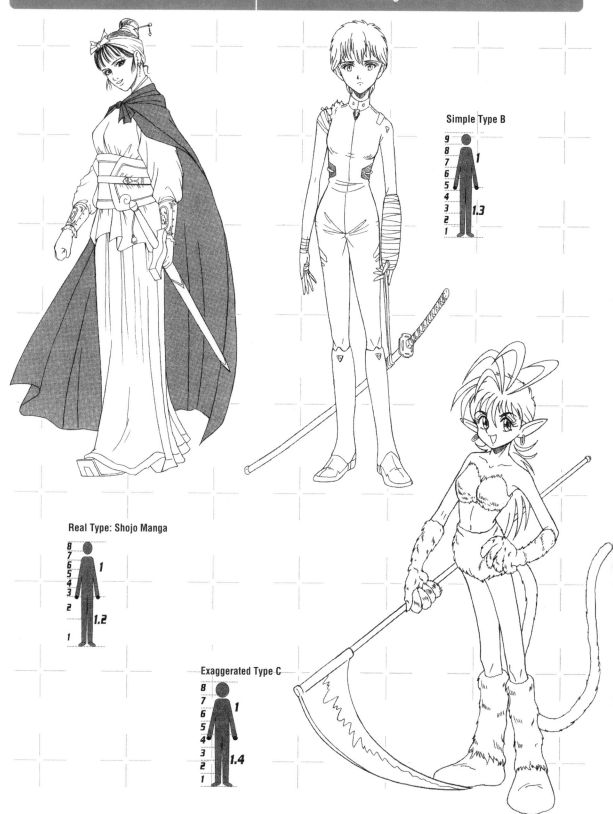

Simple Type B

9
8
7
6
5
4
3
2
1

1

1.3

Real Type: Shojo Manga

8
7
6
5
4
3
2
1

1

1.2

Exaggerated Type C

8
7
6
5
4
3
2
1

1

1.4

For every character, there are some poses that make them look great and others that are best avoided. Here is a collection of the best standing poses for some of the characters featured in this book. Have a look at them. Use this to find the best poses for your original characters.

So what do you think my body proportion is then?

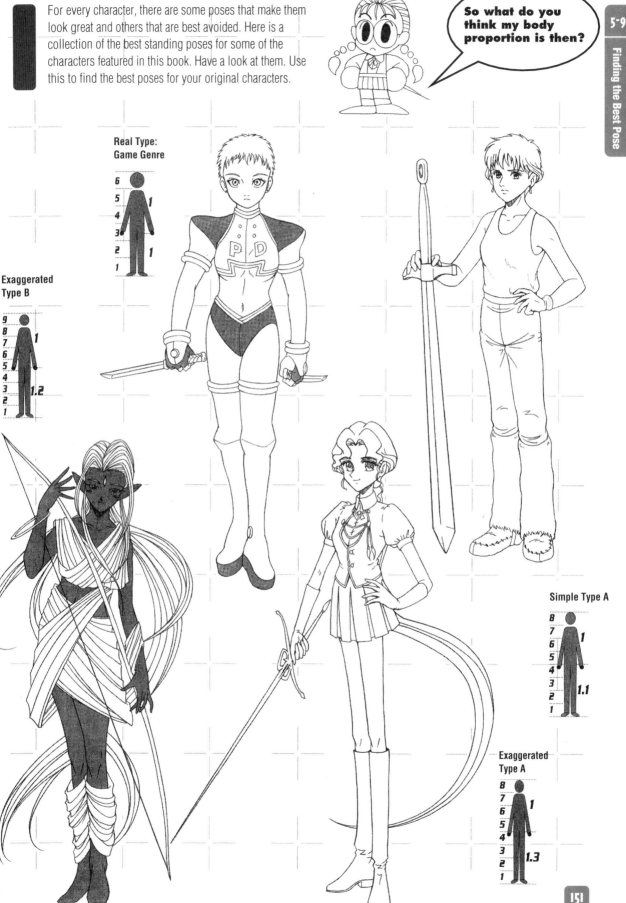

Real Type:
Game Genre

Exaggerated
Type B

Simple Type A

Exaggerated
Type A

Tadashi Ozawa:

A freelance animator, Ozawa has done contact work for such companies as Studio GHIBLI and Mad House. He took part in several hit works-The Art of NAUSICCA, LAPUTA, AKIRA, LODOSS WARS and YAWARA! An animation director at Studio GHIBLI, he worked as a producer at Mad House and was in charge of training new animators.